GERMAN DRAWINGS

from a private collection

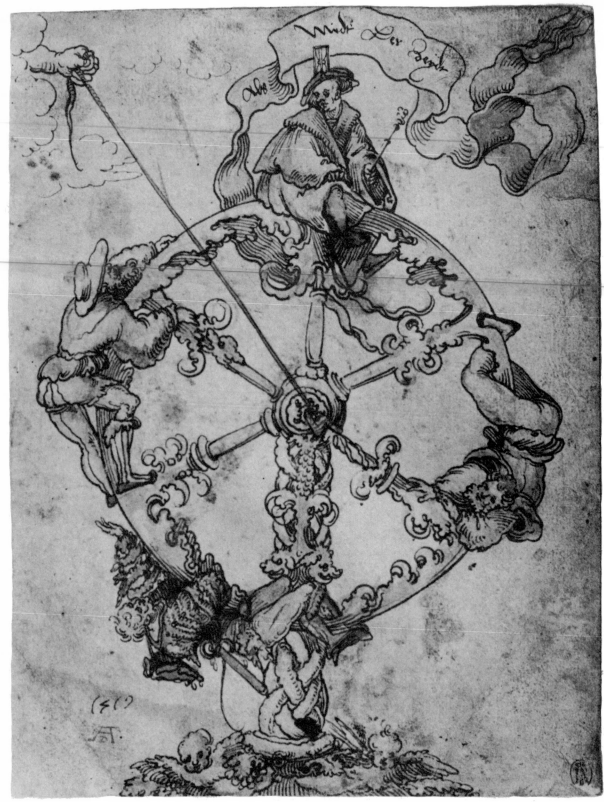

Cat. no. 34

GERMAN DRAWINGS

from a private collection

John Rowlands

BMP Published for the
Trustees of the British Museum by
British Museum Publications Limited

Acknowledgements

The Trustees of the British Museum wish to express their
gratitude to the anonymous owner of these drawings for
her generosity in making available for the first time to a
wider public a substantial part of her collection. The
catalogue is largely based on the comments and findings
of the Collector whose identity, at the owner's request, is
not revealed.

Miss Giulia Bartrum, Research Assistant, and Martyn
Tillier, Executive Officer, in the Department of Prints
and Drawings have had the arrangements and the
minutiae of the exhibition in their capable hands.

It is a pleasure to record here that subsequently this
exhibition will also be shown in the National Gallery of
Art, Washington D.C., and in the Germanisches
Nationalmuseum, Nuremberg.

Exhibition dates
British Museum, London 9 February to 29 April, 1984.
National Gallery of Art, Washington 27 May to 8 July,
 1984.
Germanisches Nationalmuseum, Nuremberg 2 August
 to 23 September, 1984.

©1984 The Trustees of the British Museum
Published by British Museum Publications Limited,
46 Bloomsbury Street, London WC1B 3QQ

ISBN 0 7141 0799 9

Designed by Harry Green

Printed in Great Britain by W. S. Cowell Ltd. Ipswich

Contents of Catalogue

Introduction

To the public at large, art collectors are chiefly thought of, when they are considered at all, as a rich, highly privileged race apart, who indulge their taste in an exotic, film-star existence supported when necessary with the advice of world experts. Such people do exist but like their taste are both rich and rare. Television, the public relations industry and the advertising campaigns of the large international auction houses, while in some respects broadening their public's interest, and of course markets, by the seductions of sensational high prices, have tended to obscure too much of the wider world of art collecting. This is inhabited by a whole range of individuals, most of whom differ strikingly from the multi-millionaire stereotype as well as from one another both in their interests, aims, social and cultural background, educational attainments as well as means. But while they are all united in their desire to possess, at least their motives in doing so are as varied as their temperaments and characters. Collecting can, and has, produced some very disagreeable prodigies, some of whose worst characteristics are pilloried in the wonderfully repellent creation of Wilkie Collins in 'The Woman in White'. As we recall, Mr Frederick Fairlie of Limmeridge House reclined fretfully in the midst of his treasures, destroyed by his 'nerves', but securely uncontaminated by any contact with the vulgarities of the outside world. We might pity this effete creature, but for the fact that his collecting passion went beyond his paintings and *objets d'art* to people. His contact with others was largely through possession, tellingly echoed in his greeting of the newly arrived drawing master – 'so glad to possess you at Limmeridge, Mr Hartright'.

This selfish recluse of fiction could not be in more pointed contrast to the approach of the Collector, a selection of whose drawings are the subject of this exhibition. Fascism cut short an already established career in a famous German museum, and like many others he took refuge outside the Third Reich. Settling in England, which thereafter was his home, he pursued his study of drawings and as opportunity permitted formed a collection of them which includes, as well as drawings by artists of the German school, examples of the work of Correggio, Raphael, Parmigianio, Claude and others. For as it will be seen from the catalogue, his collecting was always a stimulus to his scholarship. New acquisitions often raised questions which required and received answers in articles. All this was done with slender financial means but furthered with single-minded dedication.

The collecting began in the midst of the last War, when interest in such matters was at a very low ebb, prompted by a need to study drawings at first-hand. With wide specialist knowledge and considerable experience previously gained in acquiring drawings for a major continental museum, it was possible from time to time to make a discovery or a judicious purchase. In those days Old Master drawings being much more plentiful and knowledge in many fields often scanty and inaccurate, one could find items of rare interest for what now may seem ludicrously small sums. In this he was also partly aided by a certain lack of interest on the part of most other collectors in early northern drawings. For in England then, as indeed to a large extent now, the Old Master drawings that have received most attention from scholars and collectors alike were and are those of the Italian school. They were, and are of course, much more abundant, although the supply of first class

works is now very much diminished. So he had the advantage, as he described the situation, of being the collector of 'the Master of the ugly drawing'. This rather deprecating description of his own taste points to certain preconceptions about good taste and what is thought to be beautiful in art. The creative artist may say, like Picasso, 'the beautiful doesn't matter to him'. The artist has his freedom and the connoisseur should strive for this too, even though what may be exciting and stirring to him or her may be branded by others as 'ugly'. After all, we do not have to accept Nietzsche's dated moralising notion that 'ugliness' is a sign or symptom of degeneration. In matters artistic we are predisposed towards some forms of expression rather than others. Education or lack of it, experience and the stimulus of the imagination do the rest. Our understanding of tradition and the practices of past ages and the aims and purposes of artists and their works must play a vital part in our consideration of this, especially where our appreciation of the work of the German draughtsmen of the fifteenth and sixteenth centuries is concerned.

The collection is full of little gems. Indeed, many drawings are quite small in size although not in interest. Virtue was made of limited resources, which is best illustrated by the fact that the majority of these small drawings were collected to be placed as gifts in his wife's pocket-size album, an idea he conceived in 1947.

The earliest drawing in the exhibition, the *Christ Carrying the Cross,* by a Viennese artist of *c.* 1410/20, is an outstanding survival from a period when there exists few drawings of the same quality to rival it, even in the main European public collections. Like a number of other important works, before its acquisition it was unknown and its true identity and significance quite unrecognised. The *Ecce Homo,* the preliminary design by Dürer, was likewise acquired in this way. Others were recognised in the auction room, which even in these days of detailed cataloguing is still in hunting ground for the hopeful. More examples of such finds are *The Angel* by Schongauer and the early Baldung of the *Virgin on the Crescent Moon.* Many, however, came from famous collections, notably those of the Princes of Liechtenstein, Count Lubromirski, the first Lord Burlington and Henry Oppenheimer.

In sum this exhibition demonstrates to us very clearly what it has been possible to do in the relatively recent past with a keen erudite eye. Only in one instance was a mortgage needed to acquire a major drawing – the *Wheel of Fortune* by Hans Weiditz! The Collector was not a proud possessor in a covetous sense for he felt that the drawings were merely entrusted to him. They were always made freely available to scholars, collectors and interested amateurs, and it is now in this spirit of curatorship that they are displayed in the British Museum.

Anonymous Masters of the 15th Century

Viennese Master (c. 1410/20)

I *Christ carrying the Cross*

Pen and black ink with black wash, heightened with
 white bodycolour, on a greyish green ground, on
 vellum. 19.5 × 16.2 cm

Provenance: from a sixteenth-century album of Hungarian
 origin, which contained mainly prints.

Literature: the owner's private catalogue, p.17, no.2.

The figures have a close affinity with those in the
paintings of the Master of the Vienna Adoration,
so-called after a painting the *Adoration of the Christ
Child*, by an early fifteenth-century artist evidently
working in Vienna (see Elfriede Baum, *Katalog des
Museums Mittelalterlicher Österreichischer Kunst,
Österreichische Galerie, Wien*, 1971, pp. 28–29, no.
10). There exists an incomplete series of panels with
scenes from the Passion (formerly in the Durrieu
collection, Paris), which lacks the subject of this
drawing. But it is impossible to say whether the
drawing could be a record of a missing panel from
the series, and in any case an attribution to this
Master can only be tentative.

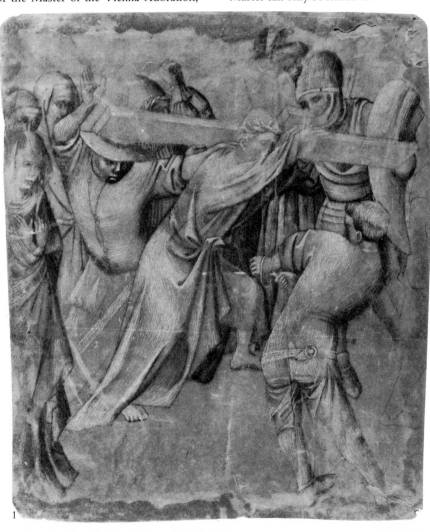

1

Austrian or Bohemian (*c.* 1430)

2 RECTO: *Resurrection*
 VERSO: *Lot and his Family fleeing*
 from Sodom

Pen and black ink, with touches of red wash and washes
 of yellow and green, on vellum. 8.4 × 9.5 cm
Provenance: Max Bonn; Robert von Hirsch.
Literature: the owner's private catalogue, p.15, no.1.

This sheet comes from a *Speculum Humanae Sal-*

vationis (the Mirror of Human Salvation), of which
many manuscript copies still exist, produced as an
aid to the poor clergy in their teaching. Like the
Biblia Pauperum (the Bible of the Poor), another
similar late medieval work of didactic synthesis, the
Speculum was intended to draw a parallel between
events in the Old and New Testaments to demons-
trate their similarities and contrasts.

 It is difficult to pinpoint the region from which
this sheet has come. Both Austria and Bohemia have
been suggested, of which Professor Otto Pächt is
inclined to favour the former.

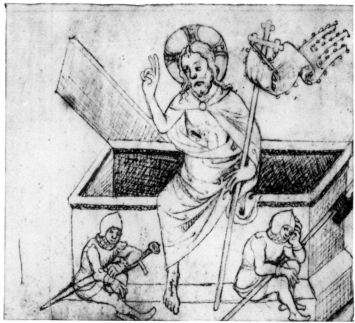

2

Thuringian (*c.* 1430)

3 *John the Baptist and St John the Evangelist*

Pen and black ink with red wash, heightened with white
bodycolour. 12.7 × 9.3 cm
Provenance: Richard Philipps, Lord Milford (Lugt,
Suppl. 2687) thence by descent to Sir John Philipps,
Picton Castle, Pembrokeshire; F. C. Springell (Lugt,
Suppl. 1049a).
Literature: Ten German Drawings, in Museum pamphlet,
Boston, Museum of Fine Arts, 1958; the owner's
private catalogue, p.19, no.3.

Until the last quarter of the fifteenth century the
surviving drawings by German artists, usually
executed as records of existing works rather than
preparatory studies, are often difficult to associate
with particular artists. In this case the Collector was
able to assign this drawing to Thuringia through a
comparison with paintings of *c.* 1430 from that reg-
ion, such as two panels now in Nuremberg (*Katalog
des Germanischen Nationalmuseums*, 1936, pp. 179–80,
nos. 10, 11), wings of an altarpiece from a workshop
in Erfurt, which produced the chief altarpieces for
the district around this town at that period.

Nuremberg Master (*c.* 1480–90)

4 *The Mocking of Christ*

Pen and black ink, with green and reddish brown washes.
14.1 × 12 cm
Provenance: On the Paris art market, *c.* 1938.
Literature: Exposition de dessins du XVᵉ au XXᵉ siècle, Max
Bine, Paris, 1927, no. 10; the owner's private catalogue,
p.41,no.13.
Inscribed by a later hand with a false date, 1467.

This is a characteristic product of the circle of Michel
Wolgemut (1434–1519), the dominant painter of his
generation in Nuremberg and Albrecht Dürer's
master. The Collector considered it specifically a
work of a master of Wolgemut's workshop and on
the comparison with woodcuts in Hartmann
Schedel's *Weltchronik* (the famous 'Nuremberg
Chronicle'), published by Anton Koberger on 12

July 1493, conceived the possibility of it being by
Wilhelm Pleydenwurff, who is mentioned as
Wolgemut's partner in that ambitious and very suc-
cessful venture.

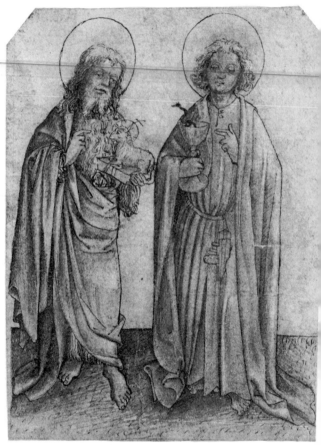

3

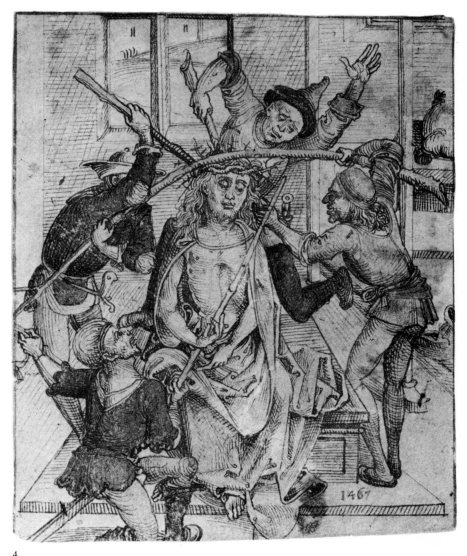

4

Strassburg Master (*c.* 1490)

5 *A hanging piece of Drapery*

Pen and brown ink. 15.7 × 7.7 cm
Literature: the owner's private catalogue, p.217, Album
 no.56.
Inscribed by the artist in brown ink at the foot, *ziegell
 v . . .,* and up the right-hand side, *liechten botze[n]vnd
 winstein in scych kachlen durchemander brenen vnd wol
 riben.*

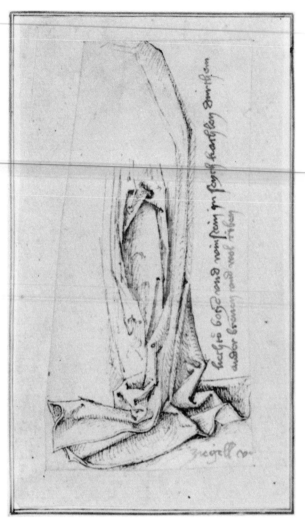

5

This drawing and no. 6 are both attributed to an
unidentified master who has been called the Master
of the Coburg Roundels or the Master of the Drap-
ery Studies. A large number of the group of draw-
ings which, apart from drapery studies like the
present drawing, are mostly copies of paintings,
engravings, sculpture and glass-paintings, were
published by F. Winkler (*Wallraf-Richartz Jahrbuch,*
N. F., i, 1930, pp. 123–52) as the work of a single
artist. In all some two hundred drawings are
classified under the alternative names the master is
given, in the print rooms of the world. It is by no
means certain, however, that all these drawings are
by the same hand; indeed, there are quite strong
stylistic grounds for suggesting that they are not.
Many of the best quality have been convincingly
associated by F. Anzelewsky (*Zeitchrift für Kunstwis-
senschaft,* xviii, 1964, p. 43 ff) with the work of the
glass-painters of Strassburg, especially Peter Hem-
mel (active *c.* 1462–*c.* 1485). Much of the rest of the
drawings, according to Anzelewsky, might be attri-
buted to a follower of the Master of the Hausbuch
(active in the Middle-Rhineland, probably in Mainz,
c. 1475–*c.* 1500). The present drawing and no. 6
belong to this second group, comprising drawings
usually specifically attributed to the Master of the
Drapery Studies. Even so, it is unlikely that both
these drawings are by the same hand.

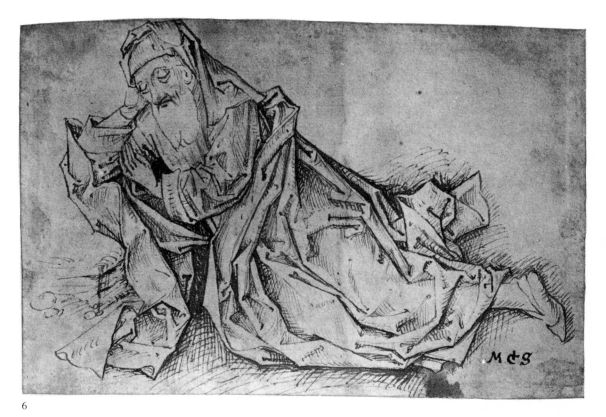

6

Strassburg Master (*c.* 1490)

6 *An Old Man, probably Jesse, sleeping on the Ground*

Pen and brown ink. 12.5 × 20.1 cm

Literature: Old Master Drawings, exh. cat., Colnaghi, 1952,
 no.6, as 'Master of the Coburg Roundels'; the owner's
 private catalogue, p.53, no.19.

Inscribed in the lower right-hand corner with a false
 Schongauer monogram.

See no. 5.

Martin Schongauer
(?Colmar *c.* 1445–Breisach 1491)

7 *An Angel*

Pen and brown ink. 17.1 × 8.7 cm

Provenance: sale Sotheby's, 1958, 5 February, lot 2, as 'German School'.

Literature: *Ten German Drawings,* Boston, Museum of Fine Arts, in Museum pamphlet, 1958; F. Winzinger, *Die Zeichnungen Martin Schongauers,* 1962, no.43; ditto, *Zeitschrift des Deutschen Vereins für Kunstwissenschaft,* xxxiii, 1979, p.27; The owner's private catalogue, p.23, no.5.

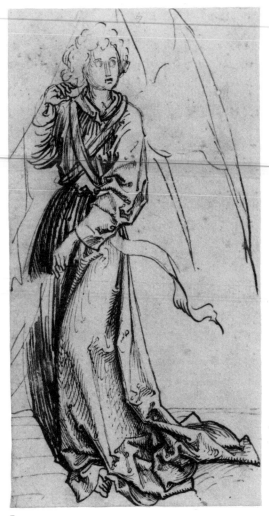

7

This and a similar drawing of an angel in the British Museum (no. 8) are almost certainly intended to be studies for parts of the same composition, and should also be connected with a further drawing, *A Man holding a Book* (no. 9) also in the British Museum. Winzinger has linked these drawings specifically with angels in the heavily damaged fresco of the *Last Judgement* in Alt-Breisach Münster, which Schongauer was working on at the end of his life. While it is not possible to see any direct connection between the drawings and this commission, it is very likely that they and *A Man holding a Book* belong to the artist's last creative phase. If we consider the angels as part of the same composition they probably would have served as attendants to either the Virgin and Child enthroned in a pavilion or under a canopy or for the Holy Trinity in a similar setting. It is interesting to note that one of Dürer's earliest drawings, now in Berlin, contemporaneous with Schongauer's late works, is of the Virgin under a canopy with such attendant angels.

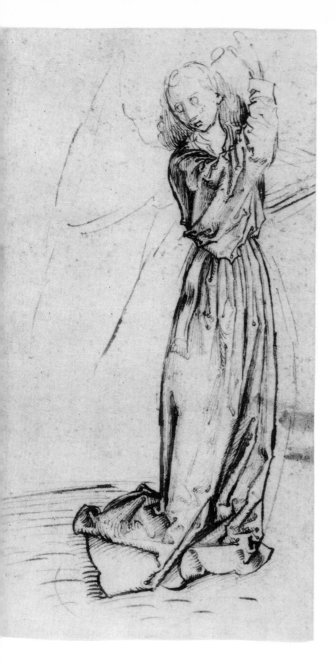

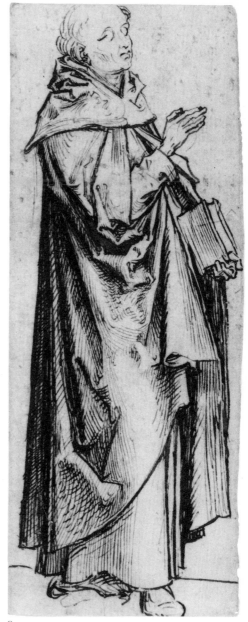

9

Martin Schongauer

8 *An Angel*

Pen and brown ink. 18.4 × 10 cm
Provenance: Sir J. C. Robinson; John Malcolm of
 Poltalloch; purchased by the British Museum, 1895.
Literature: K. T. Parker, *Alsatian Drawings of the XV and
 XVI Century*, 1928, p.25, no.11; F. Winzinger, *Die
 Zeichnungen Martin Schongauers*, 1962, no.42.

For a discussion of this drawing see no. 7.

Martin Schongauer

9 *Man holding a Book (? a Prophet)*

Pen and brown ink. Formerly joined by a blank strip of
 paper with no. 8. 18.4 × 7.2 cm
Provenance: The same as no.8.
Literature: F. Winzinger, *Die Zeichnungen Martin
 Schongauers*, 1962, no.44.

For a discussion of this drawing see no. 7.

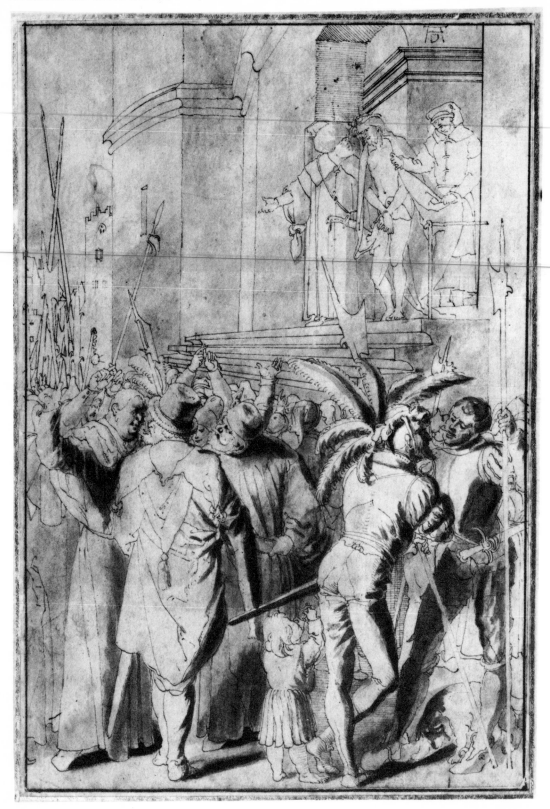

10

Nuremberg and the Upper Rhineland, First Half of the 16th Century

Albrecht Dürer (Nuremberg 1471–1528)

10 *Christ shown to the People*

Pen and brown ink, with grey wash added later.
26.5 × 18 cm
Watermark: Trident.
Provenance: evidently Sir P. P. Rubens; continental art market.
Literature: E. Schilling, *Jahrbuch der Berliner Museen*, N. F. iv, 1954, pp. 14–24; *Ten German Drawings*, in Museum pamphlet, Boston, Museum of Fine Arts, 1958; J. Rowlands, *Rubens: Drawings and Sketches,* exh. cat., British Museum, 1977, no.47; the owner's private catalogue, p.25, no.6.
Dürer's monogram has been added by a later hand.

This is a preparatory drawing for one of the series of highly finished drawings by Dürer of the Passion, the 'Green Passion', so called because they are all executed in pen and black ink, heightened with white body-colour, on a green ground. Eleven, out of a probable total of twelve, survive in the Albertina, Vienna. It is likely that the composition of the twelfth, *Christ on the Mount of Olives,* would have been based on the drawing of this subject in the Ambrosiana, Milan (F. 264 inf. 33). The *Christ shown to the People,* as in the other subjects in the 'Green Passion', in the clarity of its style and composition stands midway between the still gothic treatment in the 'Great Passion', a woodcut series, the majority of which was designed *c.* 1497–1500, and the refinement of the Engraved Passion of 1509–12. In the finished work, signed and dated *1504,* Dürer has eradicated minor confusions in the foreground of the present drawing, and with his masterly use of body-colour has given life to the dramatic scene. Although scholars are divided on the matter, I share the Collector's opinion that Rubens was responsible for the telling shading later added to the drawing.

Hans von Kulmbach (probably Kulmbach *c.* 1480–Nuremberg 1522)

11 *St Augustine with an Infant in an architectural framework on which are Adam and Eve, and God the Father, Christ Crucified, and the Dove of the Holy Spirit*

Pen and brown ink and grey wash. 26 × 18.5 cm
Provenance: with C. G. Boener, 1935; the Trier collection, Frankfurt am Main.
Literature: not known to Winkler; the owner's private catalogue, p.29, no.8.

Kulmbach was the most talented painter to emerge from Dürer's studio, who continued to work in a clearly distinctive style but still firmly grounded in

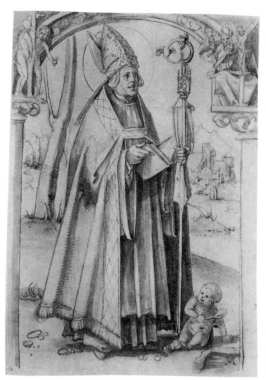

11

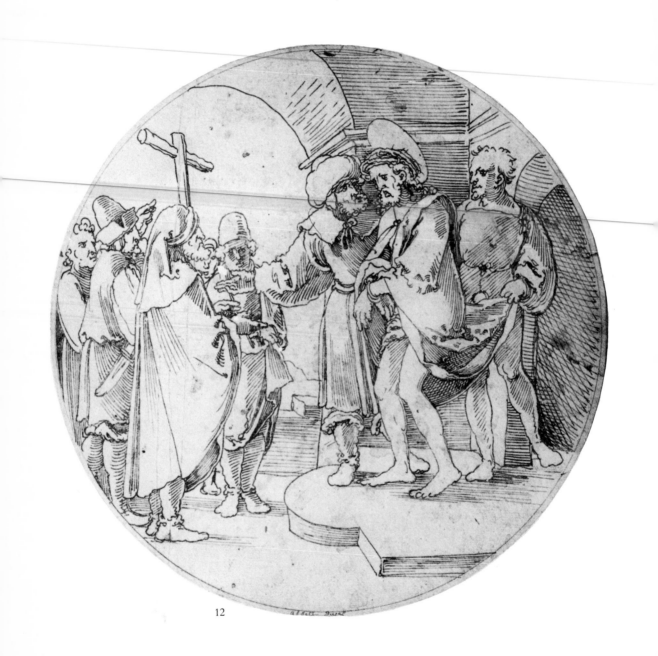

12

the master's pictorial vocabulary. The closeness of Kulmbach's continued association with his master is well illustrated by the fact that Dürer provided the finished sketch submitted to the patron for the Tucher memorial painting in St Sebald, Nuremberg, of 1513, probably Kulmbach's best known painting. The majority of his surviving designs are for glass-paintings, of which the present drawing is a typical example of one on a small scale.

Sebald Beham (Nuremberg
1500–Frankfurt am Main 1550)
12 *Christ before Pilate*

Pen and brown ink. 23 cm, diameter
Provenance: Mrs Cleeve, Guildford, Surrey;
 H. Oppenheimer, sale, Christie's, 1936, 10–14 July, lot 358(B)
Literature: the owner's private catalogue, p.61, no.23.
Inscribed with a false Dürer monogram.

Like the other glass-painting designs in his series of the Passion it is executed in Beham's rudimentary functional pen-work intended to give clear unequivocal guidance to the glass-painter.

Sebald Beham
13 *Two angles holding a Monstrance*

Pen and brown ink with grey wash over traces of an underdrawing in black chalk. 15.8 × 10 cm
Literature: the owner's private catalogue, p.197, Album no.43.

This is a preparatory drawing for an illustration to one of Cardinal Albrecht von Brandenburg's prayerbooks. Further similar designs are in the Berlin Print Room (see M. Friedländer – E. Bock, *Die deutschen Meister*, i, 1921, nos. 683–91).

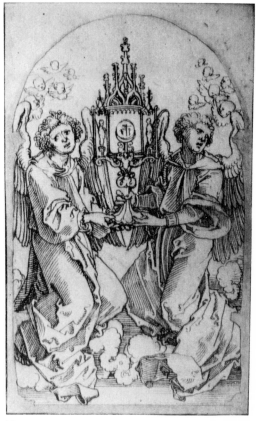

13

Sebald Beham

14 *A Putto holding a Sickle in one hand and a Bunch of Grapes in the other*

Pen and black ink. 10.8 × 9.2 cm
Provenance: A. Vivenel (Lugt, 190).
Literature: the owner's private catalogue, p.231, Album no.65.
Inscribed by the artist in black ink on the upper edge, *1542*, with below the artists's monogram added later in brown ink by another hand.

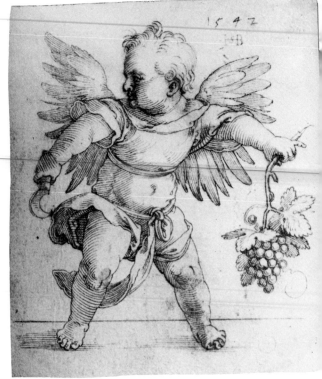

14

Peter Flötner (active, Nuremberg 1522–46)

15 *A Perspective Study: a Man lying down on a Stone Block*

Pen and black ink. 8.5 × 11.9 cm
Literature: the owner's private catalogue, p.225, Album no.61.

The clear outlines of this study, done with a fine pen, are thoroughly characteristic of Flötner, whose many-sided talents resulted in designs in a wide variety of fields. He was probably the greatest German artist of his generation, and certainly the first leading sculptor in Germany to produce works entirely Renaissance in character without any lingering vestige of the gothic style.

The present drawing arises from Flötner's lively interest in theoretical problems; however the only other work of Flötner's with which it has a formal relation is the woodcut, *The Human Sundial,* in which a prostrate, scantily-dressed peasant forms part of a dial (E. F. Bange, *Peter Flötner: Meister der Graphik* xiv, 1926, pp. 24–5, no. 11), which displays the sort of crude humour current in sixteenth-century Europe, most familiar from Rabelais.

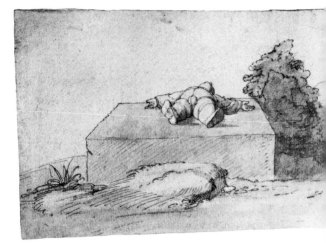

15

Jörg Pencz (Nuremberg
c. 1500–Leipzig 1550)

16 *A Young Couple*

Pen and brown ink and wash. 4.6 cm, diameter

Provenance: J. Richardson, Senior; E. Bouverie, (Lugt, 325); A. Ritter von Franck in Graz, sale, Frankfurt am Main, F. A. C. Prestel, 1889, 4 December, lot 7 as by an 'Anonymous German Master, from the first half of the 16th century'; A. Freiherr von Lanna, sale, Stuttgart, Gutekunst, 1909, 6 May, lot 79 as by 'Barthel Beham'; J. Rosenthal, Munich; F. Lugt; Dr. H. Schäffer, New York.

Literature: the owner's private catalogue, p.225, Album no.62.

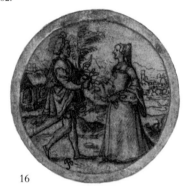

16

Pencz, a much travelled artist, as a painter developed a hard and decidedly insensitive style, and, with the exception of his dignified portraits, for the most part produced a series of clumsy essays in the Italian manner. But he was distinguished as an engraver, and his excellence as a designer on the small scale is impressively demonstrated here with a thoroughly controlled and cultivated feeling of expression. Pencz is a classic case of an artist who could only function within the confines of a strictly circumscribed area, both emotional and spatial.

The Vischer Workshop
(Nuremberg *c.* 1520–30)

17 *Arion on a Dolphin*

Pen and black ink. 7 × 6.8 cm

Provenance: S. Landsinger (Lugt, 2358); 'property of a Lady', sale, Christie's, 1952, 18 July, lot 289.

Literature: L. Baldass, in *Festschift J.v. Schlosser zum 60. Geburstag,* Vienna, 1927, p.215; the owner's private catalogue, p.205, Album no.49.

This design, which cannot, however, be connected with any of their known commissions, reflects the exuberant creativity of the Vischer foundry where the great shrine of St Sebald was being executed, most probably near the time of its completion in 1519. It shows the same playful spirit that animates the little figures enlivening its pseudo-gothic framework, which have been particularly associated with Peter Vischer the Younger (1487–1528). The present drawing's style is not, however, akin to that of other designs convincingly attributed to this member of the Vischer family.

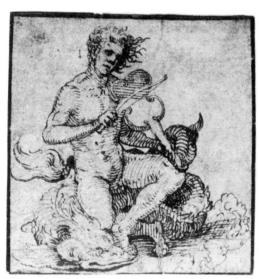

17

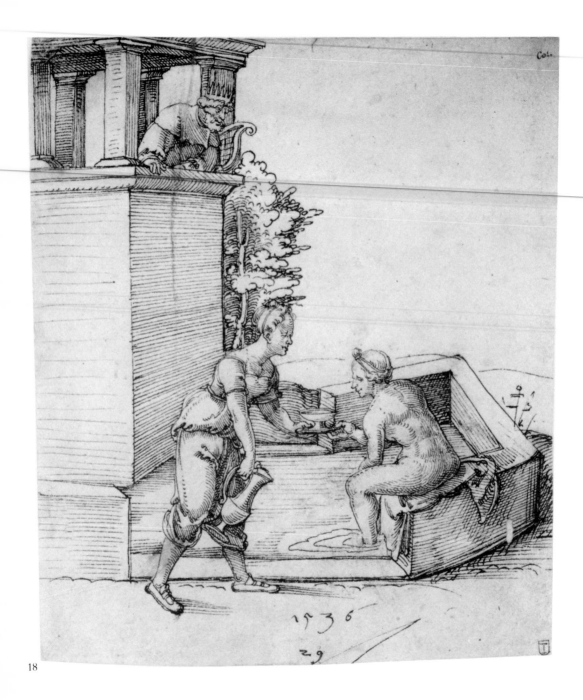

18

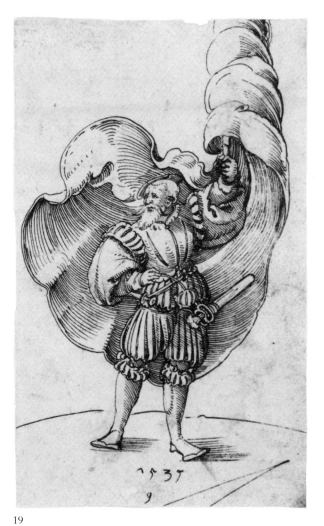

19

Erhard Schön
(active, Nuremberg 1515–50)
18 *David and Bathsheba*

Pen and black ink. 16.6 × 14.1 cm
Provenance: Wallraf-Richartz Museum, Cologne (Lugt, Suppl. 2547a); Dr J. Rech, Bonn (collector's mark not in Lugt).
Literature: the owner's private catalogue, p.69, no.27.
Inscribed by the artist in black ink at the foot of the drawing, *1536*, and the sheet number *29* with the artist's mark.

Schön mainly worked on the design of woodcuts, especially those for broadsheets, for the Nuremberg publishers. His drawings are routine work, reflecting the mundane interests of his undemanding customers. This and no. 19, both typical examples of his penwork, amply illustrate Schön's unambitious homespun mentality.

Erhard Schön
19 *A Standard-bearer*

Pen and black ink. 17.9 × 10.8 cm
Provenance: the Fürstlich Liechtenstein'sche Galerie.
Literature: the owner's private catalogue, p.233, Album no.66.
Inscribed by the artist in black ink at the foot of the drawing, *1535*, with the artist's mark and the sheet number *9*.

See no. 18.

20

Hans Baldung Grien

(Schwäbisch-Gmünd
1484/5–Strassburg 1545)

20 *The Virgin on the Crescent Moon*

Pen and black ink. 22.3 × 17 cm

Provenance: R. Udny (Lugt, 2248); Mrs M. J. Hay, sale,
Sotheby's 1953, 18 November, lot 46, as 'German
School'.

Literature: *Deutsche Zeichnungen,* exh. cat., Munich, 1956,
no.33; *H. Baldung Grien,* exh. cat., Karlsruhe, 1959,
Zeichnungen, no.99; K. Oettinger and K. A. Knappe,
Hans Baldung Grien und Albrecht Dürer in Nürnberg,
1963, p.123, no.14; J. Rowlands, *The Graphic Work of
Albrecht Dürer,* British Museum, 1971, no.318; H. Ch.
von Tavel, *Zeitschrift für Schweizerische Archäologie und
Kunstgeschichte,* xxxv, 1978, p.228; the owner's private
catalogue, p.43, no.14; Gert von der Osten, *Hans
Baldung Grien: Gemälde und Dokumente,* 1983, pp.16,
19, 42.

Inscribed by the artist in dark brown ink on the crescent
moon, *1503.*

This drawing indicates that from the very first Bal-
dung, even when working under the shadow of
Dürer, had a very distinctive style as a draughtsman,
especially with the pen. Together with the *Aristotle
and Phyllis* in the Louvre, and the *Landsknecht and
Death* in Modena, both also dated *1503,* the present
drawing is one of the earliest known dated drawings
by Baldung.

Hans Baldung Grien

21 *Head of a Fool*

Charcoal. The upper right-hand corner has been made up.
26.7 × 19.2 cm

Watermark: Eagle-head in a shield, i.e. the arms of
Freiburg-im-Breisgau (Briquet, 2207).

Provenance: Archduke Leopold Wilhelm, listed in his
inventory of 1649, as *'Eines Narrensz Kopff mit ein
Capuccio vnd offenem Maul. Mit schwartzer Kreide
gezeichnet'* (Head of a Fool in a Hood with his mouth
open. Drawn with black chalk); the Fürstlich
Liechtenstein'sche Galerie; presented to the British
Museum in memory of Edmund Schilling, 1978.

Literature: Schönbrunner-Meder, *Handzeichnungen alter*

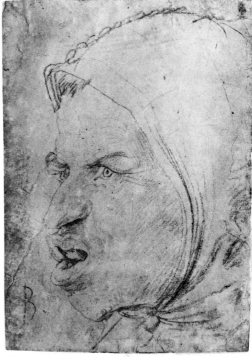

21

Meister aus der Albertina und anderen Sammlungen, no.253;
C. Koch, *Festschrift für F. Winkler,* 1958, pp. 197–200;
Hans Baldung Grien: Prints and Drawings, exh. cat.,
Washington, D.C., and Yale, New Haven, 1981, no.54;
the owner's private catalogue, p.49, no.17.

Inscribed by the artist in black chalk in the lower left-hand
corner, *B,* the second letter of the artist's monogram,
from which it is clear that the drawing has been cut on
the left.

The present drawing, together with some other
drawings also executed in chalk, at the time of the
production of his *catalogue raisonné* was not recog-
nised by Koch as a drawing by Baldung. But later,
encouraged by the Collector, Koch came to acknow-
ledge their significance in Baldung's *oeuvre.* The fool
depicted here is connected with the figure crouching
at the foot of the Cross in the Crucifixion painted on
the reverse of Baldung's high altarpiece of 1516, still
in the Münster, Freiburg-im-Breisgau. The fool
appears again in another Crucifixion by Baldung,
that at Aschaffenburg, probably dating from the late
1530s.

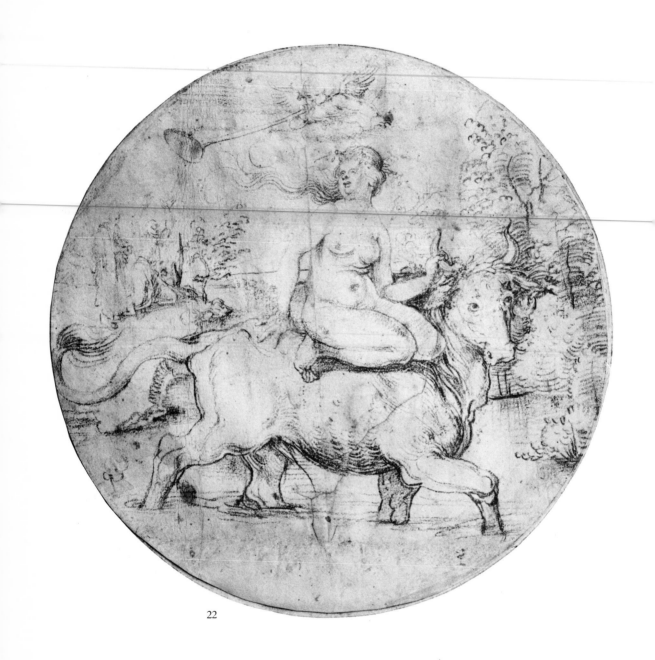

22

Hans Baldung Grien

22 *The Rape of Europa*

Charcoal. A strip of paper has been added at the foot of the sheet to make the roundel in accordance with the circle that could be described from the centre of the design, marked by a compass-point. 27.5 cm, diameter
Watermark: Ox–head (cf. Briquet, 15391–5).
Provenance: C. M. (initials on a blind stamp on the *verso*, not in Lugt); Prince Lubomirski, Lemberg (collector's mark also on *verso*, not in Lugt).
Literature: F. Winkler, *Old Master Drawings*, ii, 1927, p.16, pl.17; E. Flechsig, *Albrecht Dürer* . . ., ii, 1931, p.434; F. Winkler, *Die Zeichnungen Albrecht Dürers*, i, 1936, no.216; E. Schilling, in *Otto Pächt Festschrift*, 1972, pp.196–8; the owner's private catalogue, p.47, no.16.

After having been first attributed by Winkler to Dürer, most scholars have either rejected or doubted the attribution. Flechsig was one of the first to propose that this drawing was by Baldung but Schilling was the first not only to link this drawing with two other drawings of the same size, also designs for glass-paintings, but also to see all three as early works by Baldung done in Nuremberg when he was still working as an assistant of Dürer. These other two roundels are the *Judith and Holofernes,* regarded by Winkler as by Kulmbach, an attribution subsequently adhered to by Schade, and the very Düreresque *Death at the Open-Air Gathering*, which Winkler accepted as a drawing by Dürer. These roundel-designs were very probably executed in succession for the same client, and while Baldung still owes a certain debt to his master, Dürer, undoubtedly his own personality is already very much in evidence. This is particularly so in the present drawing in which the pose of Europa, although derived from Dürer, has been expressed in Baldung's more introspective language.

Hans Baldung Grien

23 *St John the Evangelist and John the Baptist with the arms of the Alsatian Family Bock or Böcklin von Böcklinsau*
(see Goldenes Buch der Stadt Strassburg, p. 39; Oberbadisches Geschlechterbuch, i, 1898, p. 130).

Pen and black and brown ink and grey wash. The lead-lights are indicated on the drawing in red chalk by the glass-painter. The design, originally shaped as a roundel, has been cut on the left and right, as well as being trimmed above and below. 31.3 × 24.8 cm

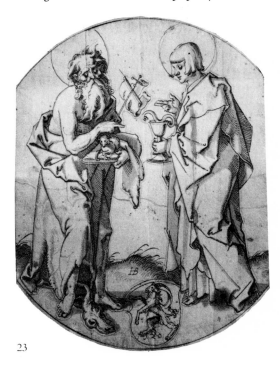

23

Watermark: High Crown with the Cross and Star (a variant not recorded in Piccard).
Provenance: in the last century it was acquired from the firm of Weigel, Leipzig, and taken to America.
Literature: the owner's private catalogue, p. 51, no. 18.
Inscribed by the artist with the brush on the arms, the artists's monogram; the glass-painter added the date *1520* and *HB* in brown ink.

Baldung was in demand as the designer of glass-paintings throughout his career, quite often having to leave it to assistants to produce some of the more stock designs, especially for the simpler heraldic glass-paintings. This is a typical distinguished example of Baldung's capacity in this field from his years of maturity soon after he had settled in Strassburg, as the glass-painter has noted, in 1520. Baldung did a further glass-painting design for this family in 1534, an *Heraldic design with a Shield and Crest, supported by a Man in Armour,* now in Berlin (C. Koch, *Die Zeichnungen Hans Baldung Griens,* 1941, p. 161, no. 159).

Hans Baldung Grien?

24 *John the Baptist*

Pen and brown ink with grey wash on a sheet irregularly cut-out and mounted on another sheet. 18.5 × 7.3 cm
Provenance: according to a note in French made on the mount this century in Paris, it came from a public sale at the Château de Saint-Leger-du-Rostre, near Bernay, Eure; then according to another note it was in England, and later on the American art market; sale, Christie's, 1963, 25–6 March, lot 103, as 'German School' (earlier in an album sold at Sotheby's, according to information from J. Byam Shaw).
Literature: L. Oehler, *Städel Jahrbuch,* N. F., iv, 1973, p. 46; the owner's private catalogue, p. 45, no. 15.
Inscribed in brown ink at the foot with a false Dürer monogram. This is one of the so-called *'geschleudertes Monogramm',* perhaps best translated as 'the carelessly

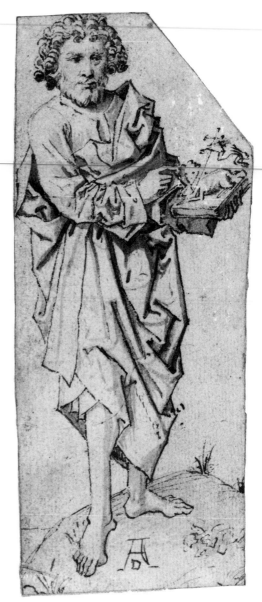

24

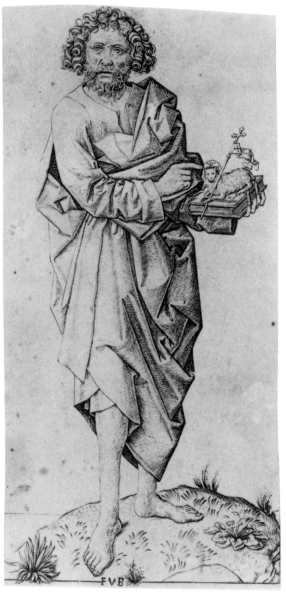

25

written monogram'. As first Parker and then Koch suggested, this was written by Sebald Büheler, a subsequent sixteenth-century owner of the drawings left by Baldung, on those drawings which he considered to be by Dürer. Büheler was an heraldic painter *(Wappenmaler)* who had inherited the Baldung-Nachlass in 1553 from his brother-in-law, the painter Nikolaus Kremer, who had been left the contents of Baldung's studio on the artist's death in 1545.

This is a copy after a print by the Netherlandish engraver, the Master F.v.B., which itself is derived from an engraving by Martin Schongauer. It was thought by both C. Koch and the Collector that this might be a very early work by Baldung. But there is no independent stylistic evidence to corroborate this suggestion, only the pointer that the early history of the drawing provides.
(See no. 25)

The Master F.v.B. (probably from Bruges, active *c.* 1480–*c.* 1500)

25 *John the Baptist*

Engraving. Cut somewhat irregularly. 18.1 × 8.9 cm
Provenance: acquired from Gutekunst by the British Museum, 1867.
Literature: Max Lehrs, *Geschichte und Kritischer Katalog des Deutschen, Niederländischen und Französischen Kupferstichs im XV Jahrhundert*, vii, Vienna, 1930, p.150, no.43 (London impression: 1st state, before the retouching by another hand and the addition of the nimbus).

This engraver, who was strongly influenced by Dirk Bouts (living *c.* 1448–75), was the most accomplished working in the Netherlands before the advent of Lucas van Leyden.
See no. 24.

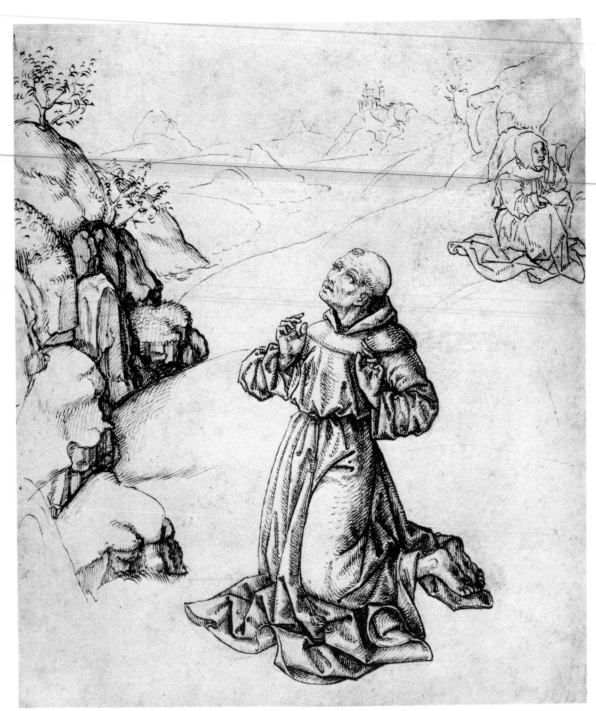

26

Thoman Burgkmair
(Augsburg 1444–1524)

26 *St Francis of Assisi with the Stigmata*

Pen and black ink over an underdrawing of black chalk.
The upper right-hand corner has been burnt.
21 × 18.1 cm

Watermark: probably Briquet, 11810.

Provenance: Count F. Sternberg-Manderscheid, sale,
Dresden, 1845, 10 November, lot 597; Freiherr R. von
Liphart (Lugt, 1758), sale, Boerner, Leipzig, 1898,
24 April, lot 873; F. Ritter von Hauslab; the Fürstlich
Liechtenstein'sche Galerie.

Literature: *Hans Holbein der Ältere und die Kunst der
Spätgotik*, exh. cat., Augsburg, 1965, no.169; the
owner's private catalogue, p.21, no.4.

The Collector, who considered the drawing to be an
unfinished sketch for a panel painting, attributed it
to Thoman Burgkmair on the grounds of its clear
stylistic links with the series of paintings with scenes
from the life of St Benedict, now destroyed, from St
Stefan, Augsburg. These paintings, in which the
head of St Benedict was depicted very like that of St
Francis in the present drawing, were credibly attri-
buted to this artist by Buchner, who also dated them
c. 1490.

School of Hans Holbein the
Elder (early sixteenth century)

27 *Bagpiper*

Pen and black ink with grey wash. 15.5 × 9.3 cm
Literature: the owner's private catalogue, p.219, Album
no.57.

In style this drawing can be readily related to the
large residue of drawings surviving from Hans Hol-
bein the Elder's very busy workshop in Augsburg,
or his immediate circle. Most of these are preserved
in the Print Room at Basel, and date from the last
decade of the fifteenth and the first few years of the
sixteenth centuries. The present example would
appear to be a drawing executed in the Master's
workshop, possibly recording one by Holbein him-
self of *c.* 1500.

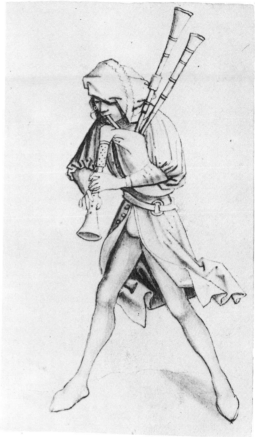

27

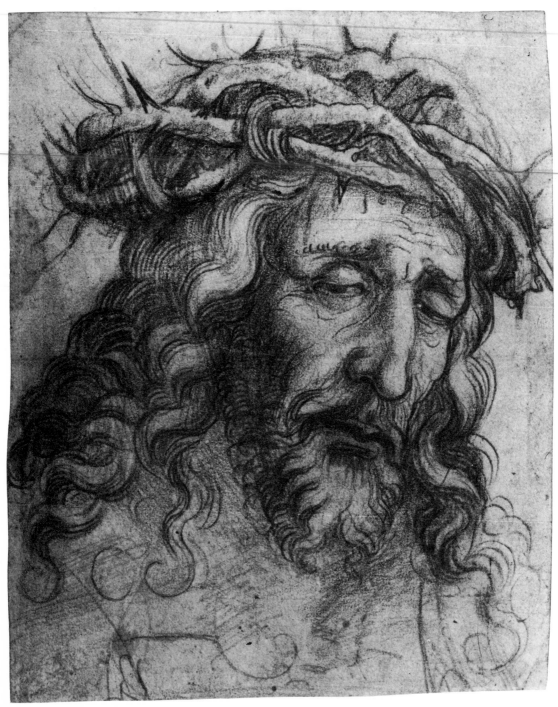

28

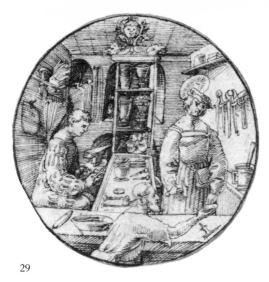

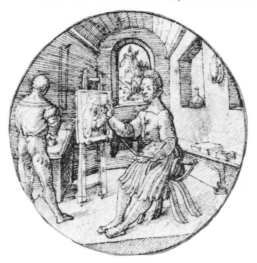

29

Hans Burgkmair the Elder
(Augsburg 1473–1531)

28 *The Head of Christ crowned with Thorns*

Red chalk. 20.5 × 16.5 cm
Watermark: Chalice (variant of Briquet, 4549).
Provenance: Freiherr R. von Liphart (Lugt, 1758), sale, Boerner, Leipzig, 1898, 24 April, lot 559, as 'Lucas van Leyden' F. A. C. Prestel, Frankfurt (Lugt, 2730); Prince Johann Georg of Saxony, sale, Ketterer, Stuttgart, 1949, 27 October, lot 1023 as 'Lucas van Leyden'.
Literature: P. Halm, *Münchner Jahrbuch der bildenden Kunst*, D. F., xiii, 1962, p.116; Tilman Falk, Burgkmair Studies, Dissertation (manuscript), Berlin, 1964, p.254, no.31; the owner's private catalogue, p.27, no.7.

Evidently it is an early work, which both the Collector and Falk have noted is based on the head of Christ in Dürer's woodcut, *Christ shown to the People,* from that portion of 'the Great Passion' which was designed in the years from about 1497 to 1500.

South German (probably Augsburg) Master (c. 1515)

29 Two Roundel Designs: a *St Eligius giving Alms in a Goldsmith's Workshop;* b *St Luke painting the Madonna in his Studio*

Pen and black ink. Each, 6.7 cm, diameter

Provenance: Ludwig Freiherr von Biegeleben (Lugt, 385); W. Koller, sale, Vienna, A. Posonyi, 1872, 5 February and following days, Drawings, lot 70 (only a listed) as by 'Hans Brosamer'; A. Freiherr von Lanna, sale, Stuttgart, Gutekunst, 1909, 6 May, lot 138; H. Oppenheimer, sale, Christie's, 1936, 10–14 July, lot 359; L. Randall, Montreal; Robert von Hirsch.
Literature: Schönbrunner-Meder, *Handzeichnungen alter Meister aus der Albertina und anderen Sammlungen,* Vienna, 1895–1908, no.1434; W. Hugelshofer, *Jahrbuch der Berliner Museen,* vii, 1965, pp.189–207, nos.37, 38; the owner's private catalogue, p.221, Album nos.58, 59.

These companion roundel designs belong to a group of similar drawings, all by the same hand, almost exclusively small roundels with a diameter on average of no more than 7 cm. The artist, probably active in Augsburg, was evidently interested in humanist themes as well as the usual religious ones, and expressed himself in a highly individual style. It is likely that the roundels were produced with some decorative purpose in mind. He was an artist, full of imagination and skill, who probably worked, like Urs Graf in Basel, more as a goldsmith than a painter.

The true character of this designer's work has only been recently properly described by Hugelshofer, who has fully catalogued the group of drawings, one of which is dated 1515, entitling their author 'The German Draughtsman of the Roundels of 1515'. Earlier, on the basis of an unconvincing comparison with the etchings of the monogrammist CB, identified by Rott as Christoph Bockstorfer, these roundels were attributed to this artist even though they were then placed in collections alongside other drawings attributed to him in various other, strikingly different styles.

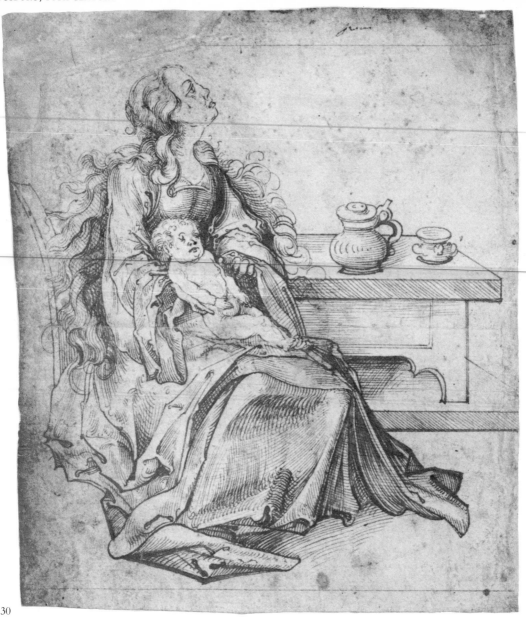

30

Jörg Breu the Elder (Augsburg *c.* 1480–1536)

30 *The Virgin and Child seated by a Table*

Pen and black ink. 15.9 × 13.6 cm

Watermark: small Bear (close to Briquet, 12270).

Provenance: it was formerly mounted in a copy of
Kellermaisterey. Gründtlicher Bericht . . ., Augsburg,
1536.

Literature: the owners's private catalogue, p.37, no.11.

Inscribed on the upper edge in an early hand, *preu.*

This is a very rare early drawing by Breu, which,
from a comparison of the representations of the
Virgin and Child in each, is very likely contem-
poraneous with the artist's first important commis-
sion, the Aggsbacher Altarpiece, signed and dated
1501, parts of which are now in the Augustiner-
Chorherrenstift, Herzogenburg, and the Ger-
manisches Nationalmuseum, Nuremberg. After vis-
its to Italy Breu later abandoned the heavy gothic
style of his early works for a Renaissance type of
design, which would readily appeal to the patricians
of Augsburg (see no. 31).

Jörg Breu the Elder

31 *Scene from a Tale in the 'Gesta Romanorum': A Duke's huntsmen finding an Infant Boy in the Woods*

Pen and black ink. 19.7 cm, diameter

Provenance: A. Grahl (Lugt, 1199) sale, Sotheby's, 1885, 27 April, lot 47 as 'Hans Burgkmair'; E. Habich (Lugt, 862); Albertina, Archduke Friedrich collection; H. Oppenheimer, sale, Christie's, 1936, 10–14 July, lot 360; E. H. L. Sexton (Lugt, Suppl. 2769c); Philip Hofer.

Literature: E. Schilling, *Old Master Drawings*, viii, 1933, pp.29–30, no.31; *Art in New England*, Boston, Museum of Fine Arts, exh. cat., 1939, no.144; the owner's private catalogue, p.31, no.9.

This design and other drawings in Frankfurt and elsewhere were made for a series of glass-paintings to illustrate Tale xx: 'Of Tribulation and Anguish', from the large collection of moral stories known as the *Gesta Romanorum* (see the translation and edition by C. Swan, revised by W. Hooper, 1876, pp. 50–52).

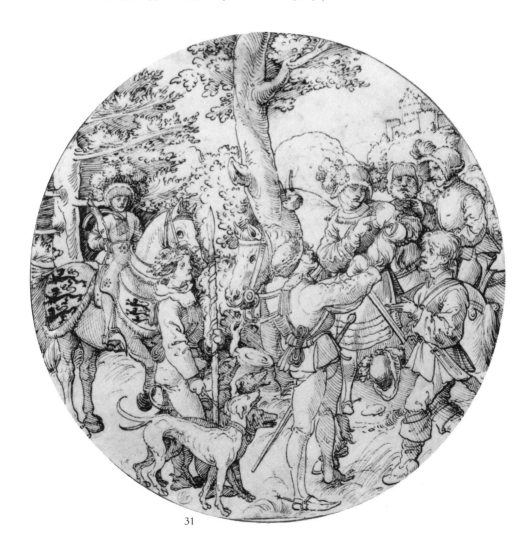

31

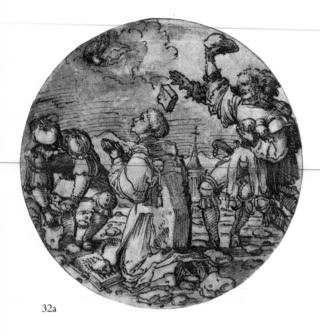

32a

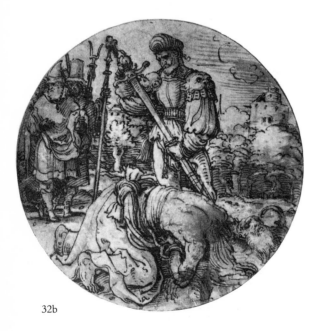

32b

Jörg Breu the Elder

32 a *Martyrdom of St Stephen;*
b *Martyrdom of St Paul*

Both pen and brown ink with grey and pink washes, with
slight traces of an underdrawing in black chalk. Each,
13.7 cm, diameter
Provenance: E. Rodrigues; J. Goldsche (Lugt, Suppl.
1310a)
Literature: J. Rosenberg, *Old Masters Drawings,* xiii, 1938,
pp.46–7, nos.46,47; the owner's private catalogue,
pp.33,35, nos.10a, 10b.

These two roundel designs for glass-paintings prob-
ably originally formed part of a much larger series of
roundels with scenes of martyrdoms of the saints.
Although unmistakably by Breu, they have been
executed with an unusually broad penline. The
majority of his designs for glass-painting are
executed in the characteristic style we find so well
exemplified by no. 31.

Leonard Beck? (Augsburg
c. 1480–1542)

33 *St Catherine*

Pen and black ink and grey wash, heightened with white
bodycolour on light brown tinted paper; the sky tinted
bright blue. 25.3 × 15.6 cm
Literature: the owner's private catalogue, p.39, no.12.
Inscribed on the verso in an old hand, *In der Manier des
Ölbildes der Hl. Barbara von H. Holbein der Münchner
Gallerie.*

The inscription alludes to the general similarity of
the pose of St Catherine to the saint on the left wing
of the St Sebastian Altarpiece by Hans Holbein the
Elder in the Alte Pinakothek (inv. no. 669). The
Collector tentatively proposed the attribution to
Beck, no doubt on the basis of a comparison with his
woodcuts of some of the female Hapsburg saints,
especially those of *Saint Ursula* and *Saint Kunegundis.*

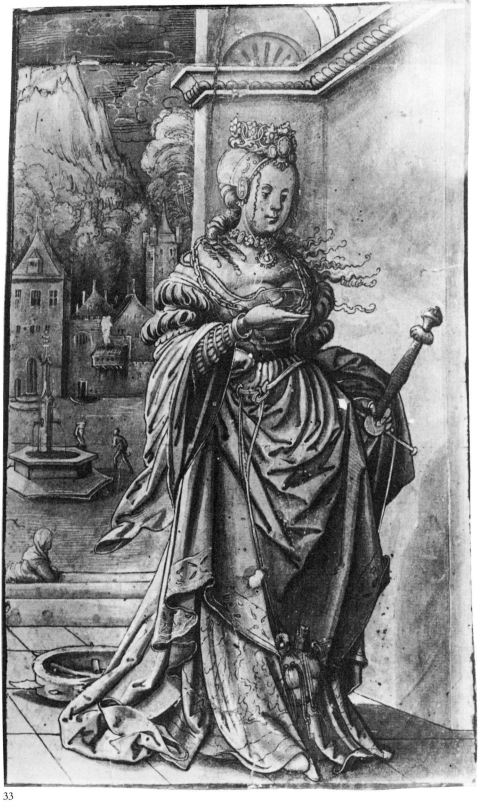

33

As Ander Buch Francisci Petrarche, vō der Artzney des bösen Glücks.

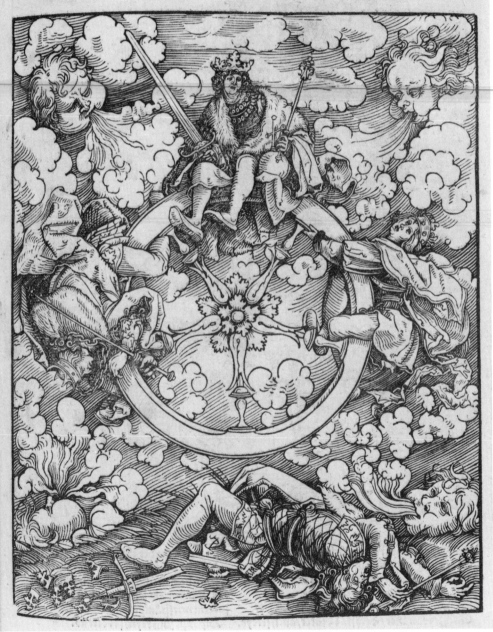

35a

Hans Weiditz (active, Augsburg *c.* 1515–22, died Strassburg, 1522–36)

34 *The Wheel of Fortune*

Pen and black ink, with yellow, red, blue, green, and grey washes. 20.6 × 15.7 cm

Provenance: Count F. Sternberg-Manderscheid, sale, Dresden, 1845, 10 November, lot 287 as 'Aldergrever'; Friedrich August II of Saxony (Lugt, 971); P. & D. Colnaghi, 1948/9.

Literature: M. Lossnitzer, *Archiv für Kunstgeschichte,* iii, Leipzig, 1913, pl.34; E. Buchner, in *Festschrift Heinrich Wölfflin,* 1924, pp.221 ff.; Th. Musper, *Old Master Drawings,* viii, 1933, p.31; *Deutsche Zeichnungen,* exh. cat. Munich, 1956, no.96; the owner's private catalogue, p.67, no.26.

Inscribed by the artist in black ink in the lower left-hand corner, *1519*, above a false Dürer mongram.

This drawing is undoubtedly connected with the three differing woodcuts of this subject that Weiditz provided as illustrations for Petrarch's 'Glücksbuch' of 1532 (see no. 35 a and b for two of the related woodcuts). It would also have been done about the same time as the artist was working on the designs for this book, the woodcuts of which were evidently completed in 1520, as the last of them bears that date. Although one cannot say that the present drawing was produced specifically for the book, it is certainly one of the finest drawings extant by this designer of genius, whose woodcuts are among the most imaginative creations of the Renaissance north of the Alps.

See frontispiece for illustration.

Hans Weiditz

35a *The Wheel of Fortune*

Woodcut. 18.8 × 14.6 cm

This is used to decorate the title-page of the second part of *Franciscus Petrarcha. Von der Artzney bayder Glück ...,* Heynrich Steyner, Augsburg, 1532, a translation into German of Petrarch's *De Remediis utriusque Fortunae,* begun by Peter Stahel and completed by Georg Spalatinus in 1521. See no. 34.

b *The Wheel of Fortune*

Woodcut, with contemporary colouring. 15.6 × 9.9 cm

In this version of the subject the folly of those who are elated by their passing good fortune are portrayed with asses heads and hindquarters. See no. 34.

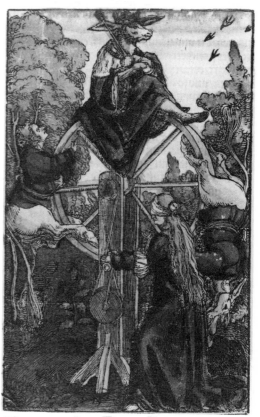

35b

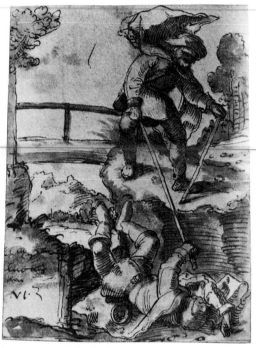

36

Hans Weiditz

36 *The Blind leading the Blind*

Pen and black ink with grey wash. 15.1 × 11.5 cm
Provenance: A. Freiherr von Lanna (Lugt, 2773), sale,
Stuttgart, Gutekunst, 1909, 7 May, lot 531, as by
'Tobias Stimmer'; Artaria, Vienna; the Fürstlich
Liechtenstein'sche Galerie.
Literature: Th. Musper, *Gutenberg Jahrbuch*, 1951, p.112;
German Art 1400–1800, exh. cat., Manchester, City Art
Gallery, 1961, no.160; the owner's private catalogue,
p.223, Album no.60.

This very freely executed drawing, no doubt
intended for a book-illustration, may be dated
*c.*1520, the time of Weiditz's production of the
designs for his woodcuts for Cicero's *Officia*, first
used in Steyner's edition of 16 February 1531.

Lambert Sustris (Amsterdam 1515/20–probably in Venice, perhaps just after 1591)

37 RECTO: *Angels making Music*
VERSO: *Virgin on the Crescent Moon*

Pen and black ink with grey wash. 22.7 × 16.9 cm
Provenance: Peltzer and Coste, Munich; Robert von Hirsch,
sale, Sotheby's, 1952, 18 June, lot 11 as by 'Peter Candid'.
Literature: the owner's private catalogue, p.65, no.25.

Sustris went early in his career to Italy where he
spent the greater part of his life as a painter. He
associated closely with Titian and may have been a
pupil of his and then a studio assistant. He was with
Titian in Augsburg for the meetings of the Reichstag
in 1548 and again in 1550–1, when he stayed for a
year. Although there is still much to learn about the
chronology of his work he evidently executed
commissions for decorative paintings which were a
speciality of his, as well as portraits of the German
nobility. Even though we cannot say that these
studies could have been executed in connection with
work done in Germany, undoubtedly he did do
some work of this nature at this relatively brief but
important moment in the artistic history of
Augsburg.

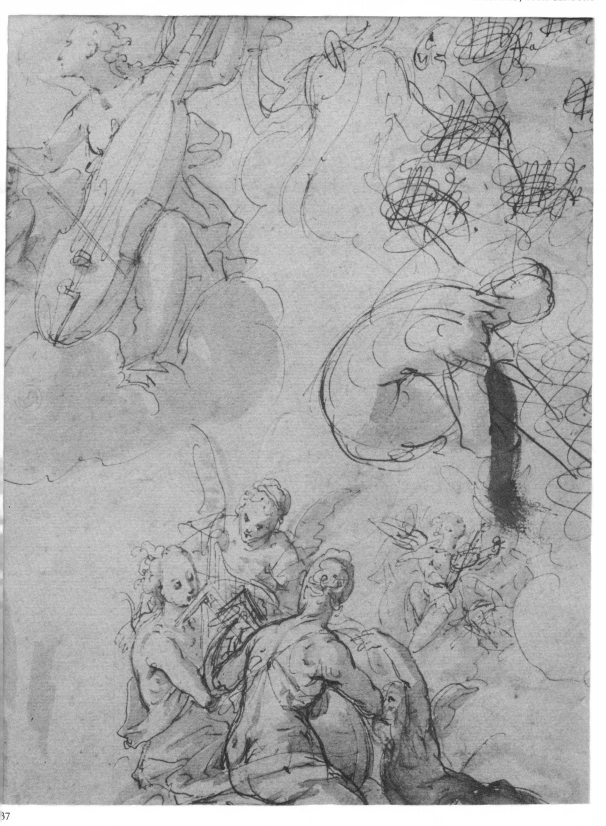

38

Attributed to Rueland Frueauf the Younger

(recorded active at Passau, 1497–1545)

38 RECTO: *Studies of Eight Scenes of Martyrdom, and St Christopher, and the Birth of Christ*

VERSO: *Head of a Horse*

Pen and black ink. The lower left-hand corner is missing.
20.5 × 28 cm

Provenance: from an Austrian noble family; G. Nebehay, Vienna; W. Schab, New York.

Literature: *Deutsche Zeichnungen*, exh. cat., Munich, 1956, no.23, as 'Bavarian-Austrian Master of the beginning of the 16th century'; F. Winzinger, *Österreichische Zeitschrift für Kunst und Denkmalspflege*, xix, 1965, p.151, as by 'Rueland Frueauf the Elder'; the owner's private catalogue, p.57, no.21.

The artist who has filled this sheet with these compact scenes has a sense of rhythmic vitality in his penwork and movement in his figures which are far more allied to Rueland Frueauf the Younger's work than to his father's, as the Collector and Peter Halm noted. Indeed, a comparison between this sheet and

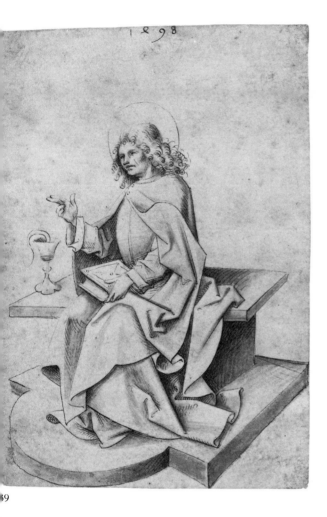

39

the similar way in which the figures around the foot of the Cross are managed in the *Crucifixion* by Rueland Frueauf the Younger, dated 1496, in the Augustiner-Chorherrenstift, Klosterneuberg, speaks strongly in favour of a fiirm attribution to this artist.

Nicholas Alexander Mair von Landshut (recorded as active, Freising 1490–Landshut 1520)

39 *St John the Evangelist seated with the Chalice*

Pen and black ink with grey wash. 19.2 × 13 cm
Watermark: High Crown (close to Briquet, 4921).
Provenance: C. Fairfax Murray; C. R. Rudolf (Lugt, Suppl. 2811b); presented to the British Museum in memory of Edmund Schilling, 1981.
Literature: J. Byam Shaw, *Old Master Drawings*, ix, 1934, pp. 35–6, no. 36; the owner's private catalogue, p. 59, no. 22.
Inscribed by the artist in black ink on the upper edge, *1498*.

This is one of only about a dozen known drawings, whose attribution to Mair von Landshut, based on three signed drawings, is generally accepted. Unlike the majority of his drawings, which have been executed in a chiaroscuro, then much used by German draughtsmen, this drawing, like a drawing in Moscow of *Simon Zelotes* of 1496, is exceptionally executed in pen and wash.

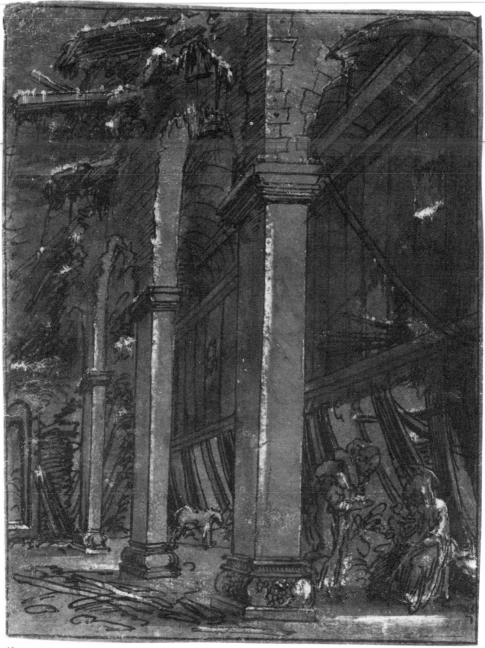

40

Bavarian (c. 1520) (?The Master of the 'Thyssen' Adoration)

40 RECTO: *The Birth of Christ*
VERSO: *A barrel-roofed interior with Women sorrowing over a dead Body*

RECTO: Pen and black ink with grey wash, heightened with white bodycolour on reddish brown prepared paper.
VERSO: Pen and black ink on light-brown prepared paper. 16.9 × 13 cm
Literature: F. Winzinger, in *Festschrift Karl Oettinger*, 1953, pp.370–1; ditto, *Wolf Huber, das Gesamtwerk*, i, 1979, p.154, no.216; the owner's private catalogue, p.189, Album no.39.

At first it was attributed to Michael Ostendorfer by Winzinger, who subsequently reattributed it to the Master of the 'Thyssen' Adoration, so-called after a painting at Lugano, an Adoration of the Magi by a close follower of Wolf Huber. As it is difficult to perceive the stylistic basis by which Winzinger linked this painting not only with the present drawing but also with the *Church Interior*, the drawing dated *1518* in Munich, which may not even be by the same hand (F. Winzinger, *Wolf Huber . . .*, i, p. 154, no. 217), it would seem reasonable to classify the present drawing as Bavarian, *c.* 1520. Both in technique and style it is a characteristic drawing of this region at that period.

Hans Wertinger (probably Landshut 1465/70–Landshut 1533)

41 *St Bartholomew with a kneeling donor, evidently a Canon*

Pen and brown ink with grey wash. 17.7 × 10.9 cm
Literature: the owner's private catalogue, p.235, Album no.67.

This is an inspired attribution on the Collector's part, as a mere handful of drawings has been attributed to Wertinger, almost always with some measure of uncertainty. If the attribution is accepted then it is probable that it would have been executed in connection with a commission for a painting of about 1500.

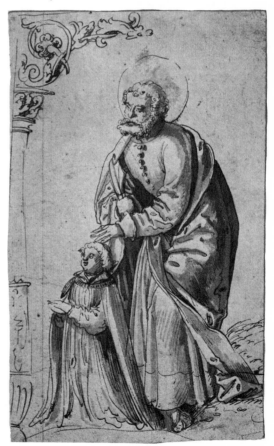

41

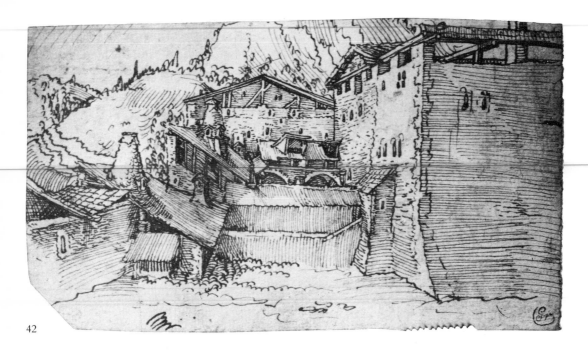

42

Augustin Hirschvogel
(Nuremberg *c.* 1503–Vienna *c.* 1569)

42 RECTO: *A Watermill at the foot of a Hill*
 VERSO: *Study of a Tree* (under the
 mount, inaccessible to view)

Pen and black ink. 8.3 × 14.7 cm

Provenance: A. Grahl (Lugt, 1199), sale, Sotheby's, 1885,
 27 April, lot 153; the Fürstlich Liechtenstein'sche
 Galerie.

Literature: the owner's private catalogue, p.205, Album
 no.48.

This drawing belongs to a group of landscapes that
have been credibly attributed to the artist, whose
works in this field often powerfully reflect the
influence of the landscapes done by Wolf Huber
(*c.* 1490–1553) from the 1530s onwards.
Hirschvogel's landscapes include all the picturesque
elements, so typical of the Danube School, but
without any of the brooding intensity that hangs
over Altdorfer's landscapes.

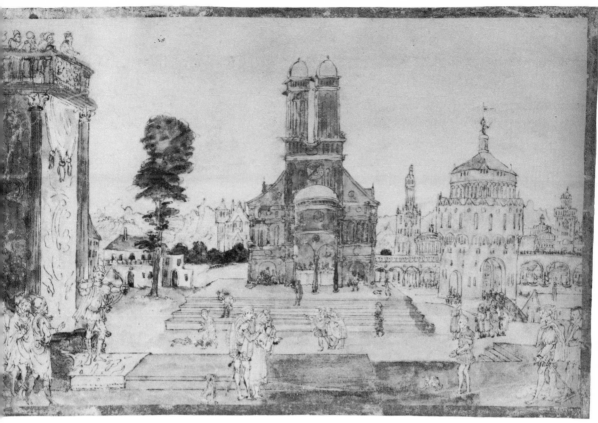

43

Ludwig Refinger (active in Landshut and Munich *c.* 1528–1548/9)

43 *The Cruelty of Cambyses* (according to Herodotus's History, Book III, Chapter 35)

Pen and brown ink, with blue, brown, grey and green washes. 21.3 × 32.5 cm
Literature: E. Schilling, *Münchner Jahrbuch der bildenden Kunst*, D. F., v, 1954, p.131 ff.; *Deutsche Zeichnungen*, exh. cat., Munich, 1956, no.100; the owner's private catalogue, p.77, no.31.

From a description of the Residence in Landshut of 1761 by a certain Fassmann, we learn that Refinger painted a decoration with the history of Cambyses, part of a scheme of moralising subjects executed with the collaboration of Hans Bocksberger and an otherwise unknown artist, Hermann Posthumus for Ludwig x of Bavaria in 1542/3, who had been greatly impressed a few years earlier on a visit to the Gonzagas with the frescoes of Giulio Romano at Mantua. A common feature of Refinger's compositions is his passion for architectural extravaganzas, in which particular he outstripped those of his German contemporaries who, like Refinger had a predilection for painting tales, usually of ancient history against a background of grandiose palaces or town squares, peopled with the protagonists of the story in question often surrounded by a throng of witnesses, who may not appear too interested in the events unfolding before them. This vogue derives partly from the elaborate settings, pseudo-Venetian in style, that artists like Sebald Beham and Jörg Breu gave to their largest woodcuts of biblical or historical subjects.

This drawing together with the other two on display (nos. 44 and 45) give a very clear picture of Refinger's strengths and weaknesses as a draughtsman.

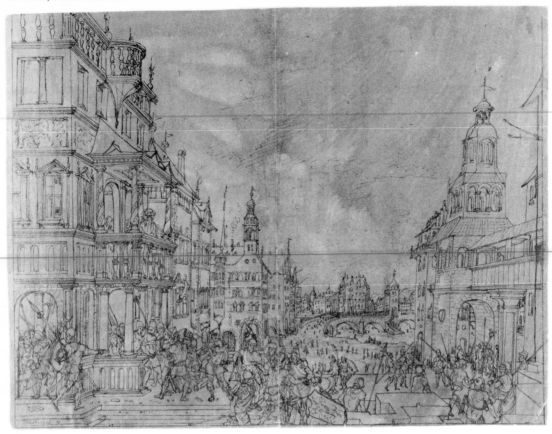

44

Ludwig Refinger

44 RECTO: *A Scene from Classical Mythology or History: probably the Arrest of Helen*
VERSO: *Further studies for the middle distance of the recto*

RECTO: Pen and brown ink on an olive-green ground.
VERSO: Pen and brown ink. 29.8 × 39.4 cm
Provenance: Sir Thomas Lawrence (Lugt, 2445); W. C. Ohly, London, 1942.
Literature: E. Schilling, *Münchner Jahrbuch der bildenden Kunst*, D. F., v, 1954, p.131 ff.; the owner's private catalogue, p.75, no.30.

This is a further example of a historical scene placed within one of Refinger's characteristically palatial settings. See also no. 43.

Ludwig Refinger

45 *Christ and the Woman of Samaria*

Pen and brown ink on grey prepared paper. 19.3 × 14 cm
Provenance: P. Prouté, Paris.
Literature: *Catalogue 'Cochin'*, P. Prouté, Paris, 1962, as 'South German, *c.* 1530'; the owner's private catalogue, p.185, Album no.37.

Compared with the other drawings that have been attributed to Refinger this is an unexpectedly traditional but nonetheless very effective treatment of the subject. For a general discussion of Refinger as a draughtsman, see no. 43.

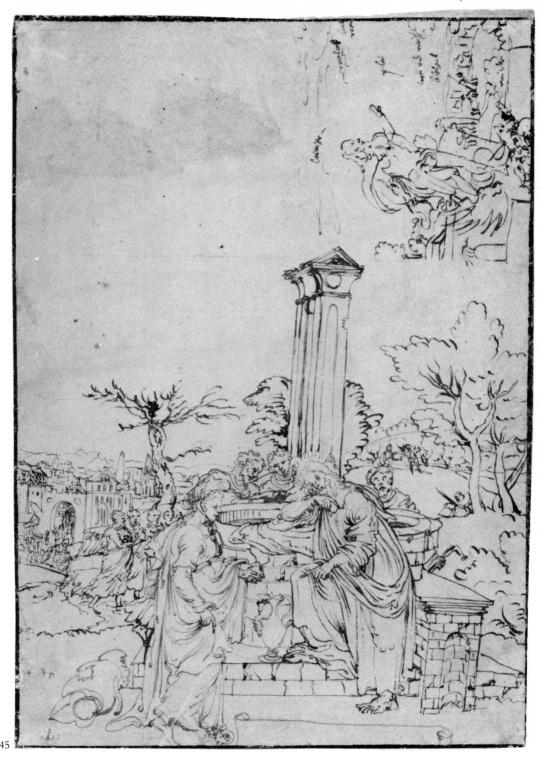

45

Saxony, North Germany and Switzerland, 16th Century

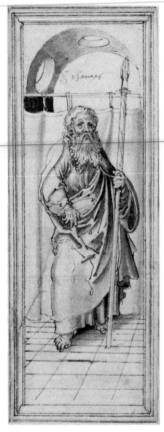

46 recto

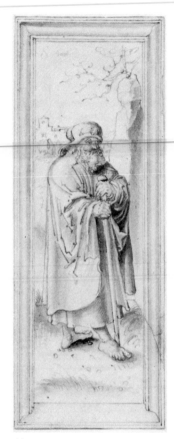

46 verso

Lucas Cranach the Elder
(Kronach 1472–Weimar 1553)

46 RECTO: *St Thomas with the Spear*
VERSO: *St Jacob as a Pilgrim*

RECTO AND VERSO: Pen and brown ink with grey wash; the
flesh touched with pink wash. 15.8 × 5.8 cm

Literature: J. Rosenberg, *Die Zeichnungen Lukas Cranachs
des Älteren*, Berlin, 1960, p.21, no.32; W. Schade, *Die
Maleŕfamilie Cranach*, Dresden, 1974, p.386; the owner's
private catalogue, p.187, Album no.38.

Inscribed by the artist in brown ink on the *recto*, S *thamas*,
and on the *verso*, S *jacb*.

This formed part of a preparatory drawing for an
altarpiece, done so that the prospective client could
have a clear indication of the appearance of the
whole with the wings open and closed. It explains
why the present drawing has been drawn on *recto*
and *verso* to represent either side of a wing with the
frame. It seems very likely, as V. Steinmann and
W. Schade have proposed, that this drawing was
executed for a wing of the St Thomas Altarpiece,
formerly in the Stiftskirche at Halle. Further exam-
ples of this kind of drawing for altarpieces by
Cranach are in the Louvre, Berlin, Weimar and
Leipzig. Although such drawings must have been
produced by other German artists at that period, few
of them have survived. A notable example by a
contemporary is that by Kulmbach in the British
Museum for an altarpiece with the Coronation of
the Virgin (Sloane 5218–124 . . . 127).

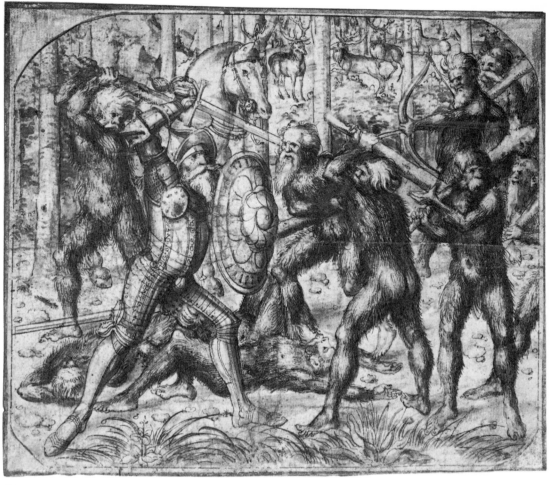

47

Lucas Cranach the Younger
(Wittenberg 1515–Weimar 1586)

47 *Hercules fighting with the Pygmies*

Pen and black ink with grey wash; the flesh lightly tinted
with red wash. The corners of the sheet have been
rounded. 18.3 × 22 cm

Provenance: Sir John E. Philipps, d. 1948 (his ex-libris on
verso of the mount).

Literature: *Old Master Drawings*, exh. cat., Royal Academy,
London, 1953, no.233; W. Schade, *Zeitschrift des
Deutschen Vereins für Kunstwissenschaft*, xxii, 1968, p.32;
ditto, *Die Malerfamilie Cranach*, exh. cat., Dresden,
1974, p.91, no.213; *Lucas Cranach*, exh. cat., ii, Basel,
1974 (published 1976), no.490; the owner's private
catalogue, p.63, no.24.

This drawing is a key example of Lucas Cranach the
Younger's considerable skill as a draughtsman. It is
clearly related to the commission to provide paint-
ings of the Exploits of Hercules to decorate Dresden
Castle, of which two paintings, both dated 1551,
The sleeping Hercules and the Pygmies and *The
awakened Hercules fights with the Pygmies* are still
preserved in Dresden.

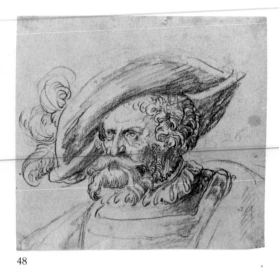

48

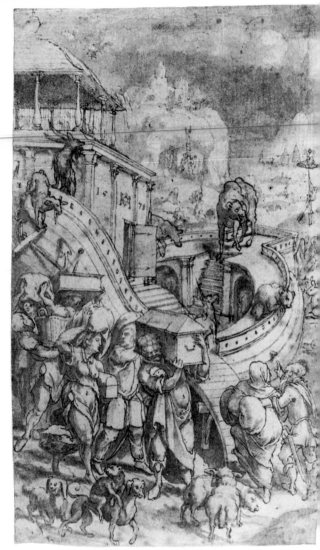

Georg Lemberger (Landshut
c. 1495–probably Magdeburg
c. 1540)

48 *Portrait of a Man wearing a Hat*

Black chalk. 18.6 × 20.5 cm
Literature: E. Schilling, *Pantheon*, xxi, 1963, pp.206–9; the
owner's private catalogue, p.55, no.20.
Inscribed by the artist in black chalk on the right, *1526*.

This drawing and another male portrait drawing
dated *1525*, in the Schlossmuseum, Weimar, clearly
by the same hand, have been very plausibly attri-
buted to Lemberger by Schilling. He did this on the
strength of a comparison with the four saints in
Lemberger's earliest known work, the frontispiece
to the *Missale Pragense,* printed by Lotter at Leipzig
in November 1522, which is his most impressive
woodcut.

49

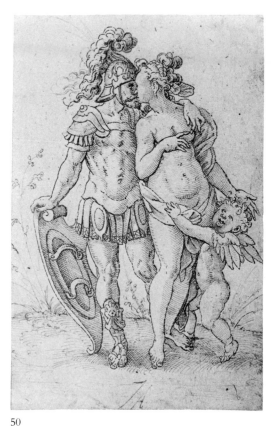

50

Hermann tom Ring (Münster, Westphalia 1521–?97)

49 *Noah's Ark*

Pen and brown ink and grey wash. 19.1 × 11.2 cm
Provenance: acquired in 1948 in exchange for a drawing by
 Piranesi from Sir Robert Witt (Lugt, Suppl.2228b).
Literature: Th. Riewerts and P. Pieper, *Die Maler tom Ring*,
 1955, p.105, no.98; the owner's private catalogue, p.71,
 no.28.
Inscribed by the artist in brown ink on the side of the Ark,
 1578 with tom Ring's monogram.

Herman tom Ring was a member of a family of
artists working in Münster in Northern Germany,
but he was the only one from whom we have any
drawings apart from still-life studies by his brother,
Ludger tom Ring (1522–1584). But perhaps that is
not surprising as comparatively few sixteenth-
century drawings by artists from North Germany,
in contrast to the great wealth of those from the
South, have come down to us. This drawing has a
companion in size, *The Burning of Sodom and Gomor-
rah* in the Landesmuseum, Münster, but more often
this artist uses the pen and brush to dramatize man-
nered, rather menacing interpretations of such
religious subjects as the Last Judgement, or the
Transfiguration.

Jost Amman (Zürich 1539–Nuremberg 1591)

50 *Mars, Venus and Cupid*

Pen and black ink. 13.9 × 9 cm
Literature: the owner's private catalogue, p.193, Album
 no.41.
Inscribed by the artist in black ink on the lower edge, the
 artist's monogram.

This is a characteristic example of Amman's fluent
use of the pen. His work is always facile in execution
and only demanding on the eye when his designs
become heavily elaborated.

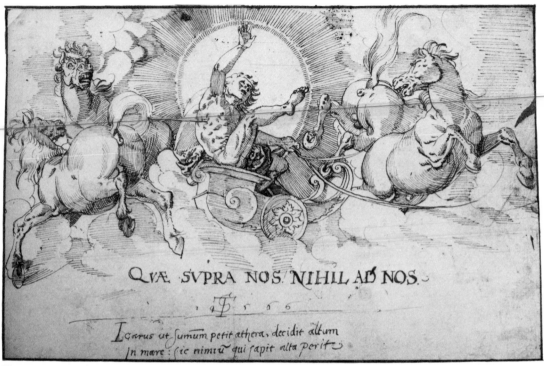

51

Tobias Stimmer (Schaffhausen 1539–Strassburg 1584)

51 *Phaeton in the Chariot of the Sun*

Pen and black ink. 18 × 28 cm

Literature: E. Schilling, *Zeitschrift für Schweizerische Archäologie und Kunstgeschichte,* xi, 1950, pp.118–20; *Ten German Drawings,* in Museum pamphlet, Boston, Museum of Fine Arts, 1958; the owner's private catalogue, p.79, no.32.

Inscribed by the artist in black ink, *QVÆ SVPRA NOS NIHIL AD NOS* with the artist's monogram, and *1566,* and below, *Icarus ut sum[m]um petit athera, decidit altum in mare : sic nimiu[m] qui sapit alta perit.*

This is an outstanding example of Stimmer's use of the pen. No doubt it was designs like this that Stimmer prepared when decorating the Margrave's Schloss in Baden-Baden with allegorical, cosmological and other frescoes in the middle of the 1570s, and again in 1583.

Tobias Stimmer

52 *House-building*

Pen and black ink. 20.6 × 17.1 cm

Provenance: S. Sybolt (Lugt, 2366); Thüring Walthard (Lugt, 2439).

Literature: *German Art 1400–1800,* exh. cat., Manchester, City Art Gallery, 1961, no.164; the owner's private catalogue, p.81, no.33.

This is a design for a glass-painting, a field in which Stimmer was a prolific provider. Such glass-paintings were in great demand to decorate the homes of the rising merchant classes, especially in Switzerland and South Germany in the second half of the sixteenth century, and throughout much of the following century. Another version of this design also executed by Stimmer is in the Landesmuseum, Zürich (inv. no. 24733), and a copy of the present drawing is at Basel.

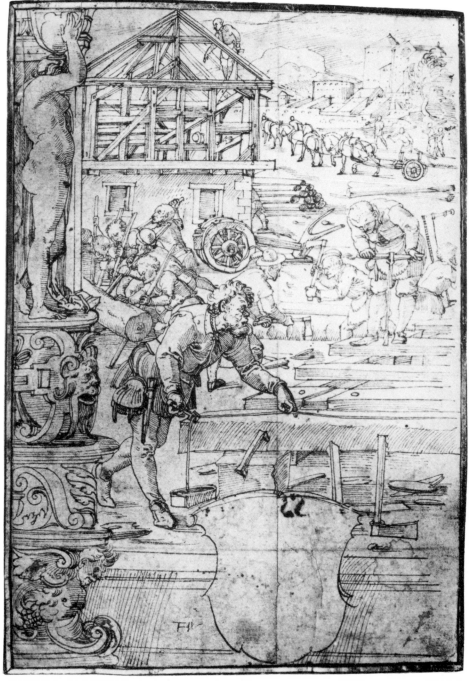

52

The Topographers of the Empire,
16th and 17th Centuries

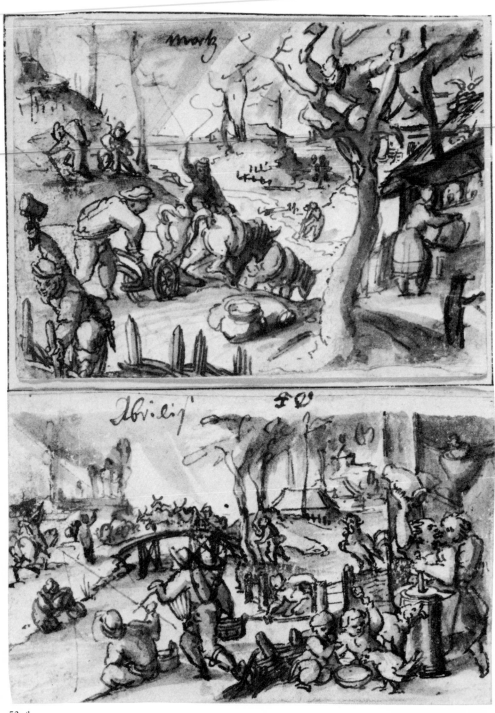

53a/b

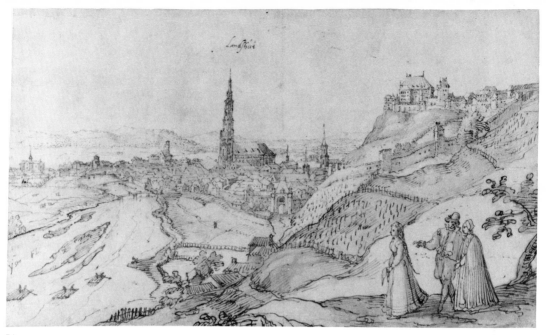

54

Wendel Dietterlin (Pfullendorf, Baden 1550/1—Srassburg 1599)

53a *The Month of March*

Pen and brown ink with brown and grey washes.
9.5 × 13 cm
Inscribed by the artist on the upper edge in brown ink, *mertz*.

b *The Month of April*

Pen and brown ink with brown and grey washes.
8.3 × 13.9 cm
Inscribed by the artist on the upper edge in brown ink, *Abrilis*.
Literature: the owner's private catalogue, p.229, Album nos. 64a, 64b.
On the *verso* of these drawings are mounted parts of a copy after a work by Christoph Schwarz of a kneeling figure in pen and black ink, inscribed *Christophorus Schwarz figuravit Augustae Vindel: 1594*.

As a natural development from the illuminations of the months that decorated the calendars of late medieval and early Renaissance manuscripts, from the middle of the sixteenth century in Northern Europe, independent landscapes, both painted and printed, especially hunting scenes and series of the months, became ever increasingly in demand. Such

subjects before long were a common decorative feature in both architecture and the applied arts, a taste which invaded England in Elizabeth I's reign. One may recall Sir John Falstaff trying to 'buy off' Mistress Quickly with the offer of 'a pretty slight drollery, or the Story of the Prodigal, or the German hunting in water-work [i.e. watercolour]'.

These two drawings are executed broadly with the pen and are thoroughly characteristic of Dietterlin, a point first made by Heinrich Geissler.

Georg Hoefnagel (Antwerp 1543–Vienna 1600)

54 *View of Landshut*

Pen and brown ink. 24.1 × 40.6 cm
Literature: *Old Masters Drawings*, exh. cat. Royal Academy, London, 1953, no.203; E. Schilling, in *Festschrift für Hans Kauffmann*, Berlin, 1956, p.233 ff.; *Ten German Drawings*, in Museum pamphlet, Boston, Museum of Fine Arts, 1958; H. Bleibrunner, *Landshut, Ansichten der Stadt aus fünf Jahrhunderten*, Landshut, 1974, p.16; the owner's private catalogue, p.83, no.34.

This is a preparatory design for the plate of Landshut (see no. 55) included in Book III of the *Civitates Orbis*

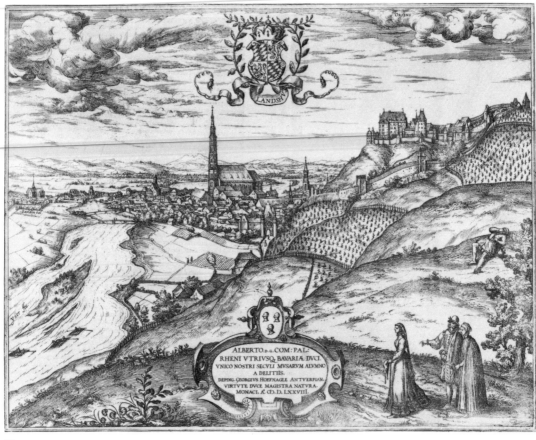

55

Terrarum (1581) published in Cologne by Georg Braun and Frans Hogenberg, the first printed uniform collection of views of the cities of the world. The majority of the views gives a valuable and often highly accurate impression of each location, which Hoefnagel provided many which are excellent panoramic landscapes. Although not born in Germany, Hoefnagel, a much travelled artist, spent much of his time in the Empire. It is fascinating to see the skilful way in which details merely suggested by Hoefnagel in this free sketch have been faithfully elaborated in the etching.

Georg Hoefnagel

55 *View of Landshut*

Engraving and etching. 39.5 × 52 cm
Inscribed with Hoefnagel's dedication to Albert, Duke of
 Bavaria and dated 1578.

See no. 54.

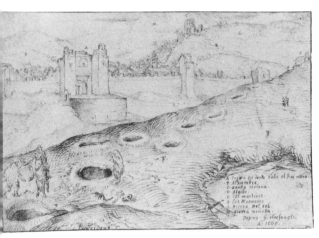

56

57

Georg Hoefnagel

56 *View of Granada, seen from the south*

Pen and brown ink. 14.2 × 20.4 cm
Provenance: Chevalier J. Camberlyn (Lugt, 514), sale,
 Paris, Expért Guichardot, 1865, 20 November, lot 177.
Literature: the owner's private catalogue, p.227, Album
 no.63.
Inscribed by the artist in brown ink with a key to
 locations, *Deping. G: Hoefnagle 'a': 1565.*

Two small plates, one of the Gate of the Alhambra at
Granada, and the other of pits called *Masmoros* with
the Chapel of *Los Martires* before the city walls, were
derived from this sketch for inclusion in Book V
(*c.* 1598) of Braun and Hogenberg's *Civitates Orbis
Terrarum.*

Georg Hoefnagel

57 *Allegory of Life and Death: 'Vitam non mortem recognita'*

Gouache painting, illuminated with gold leaf on vellum.
 16.8 × 23.7 cm
Literature: the owner's private catalogue, p.85, no.35.
Inscribed above by the artist, *Pragae 1598 Joris Hoefnagel.*

This minature, in excellent condition, represents
extremely well an important aspect of Hoefnagel's
activity. He illuminated for the Emperor and others
a series of manuscripts with texts in elaborate calligraphy with richly ornamented borders, frequently
of animals, birds and insects, observed in minute
detail as in the present miniature.

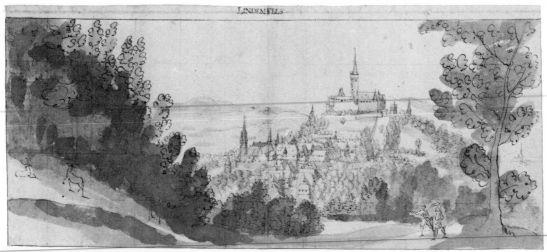

58

Mathaeus Merian the Elder
(Basel 1593–Schwalbach, near Frankfurt, 1650)

58 *View of the Town and Burg Lindenfels in the Odenwald*

Pen and black ink with grey wash, and squared for
transfer in black chalk. 14.8 × 33.9 cm
Provenance: R. Edwyn Lyne (Lugt, Suppl. 1697e);
B. Delany (Lugt, 350).
Literature: H. Eckhardt, *Mathaeus Merian*, Kiel, 1892,
p.199; the owner's private catalogue, p.97, no.41.

Merian, even more than Hoefnagel, was a specialist
in the designing of views for engraving. He became
the leading publisher on the Continent of topogra-
phy in the first half of the seventeenth century,
taking over in 1625 the publishing firm of his
father-in-law, Johann Theodor de Bry. In the course
of his career he published over two thousand views
of towns, not all of which he had the time to draw
himself. A typical example by him is this view of a
small town in the Odenwald not far from Frankfurt
am Main where his workshop was, and where
Wenceslaus Hollar received early employment and
very useful experience. The business was continued
after Merian's death by his son of the same name,
who had been a pupil of Joachim von Sandrart, and
an assistant of Van Dyck in London.

Wenceslaus Hollar (Prague
1607–London 1677)

59 RECTO: *View of Hermenstein = Ehrenbreitstein, seen from Coblenz*
VERSO: *View of the Kloster Bornhofen (?) and the Crane at St Goar or Boppard*

RECTO: Pen and black ink with brown and blue washes.
VERSO: Graphite. 5.9 × 17.7 cm
Literature: Francis C. Springell, *Connoisseur and Diplomat*,
London, 1963, p.171, under no. XI (*recto*), p.173, under
no. XXI (*verso*); R. Pennington, *A descriptive catalogue of
the etched work of Wenceslaus Hollar 1607–1677*,
Cambridge, 1982, p.124, under no.724 (*recto*); the
owner's private catalogue, p.247, Album no.73a.
Inscribed on the *recto* by the artist in black ink on the
lower edge, his monogram and 1632 (the last two
figures have been subsequently gone over) with above
the hill on the right, *Hermenstein* and on the river,
Rhenus fl[uvius].

This is the preparatory drawing for the etching (see
no. 60), evidently executed as a result of Hollar's first
journey down the Rhine to Cologne, after he left the
workshop of Mathaeus Merian in Frankfurt am
Main in 1632. Subsequently, when he was travelling
with the Earl of Arundel on his Imperial Embassy,
Hollar recorded this location again from a similar
view-point with circumstantial details of the Earl's
progress in a drawing, dated *10 Maij 1636*, now at
Chatsworth, no.76 (F. C. Springell, *op. cit.* p. 171,
no. XI); two further drawings with similar views,

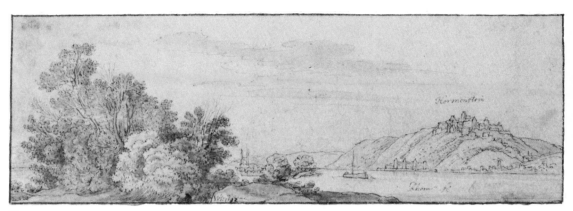

59

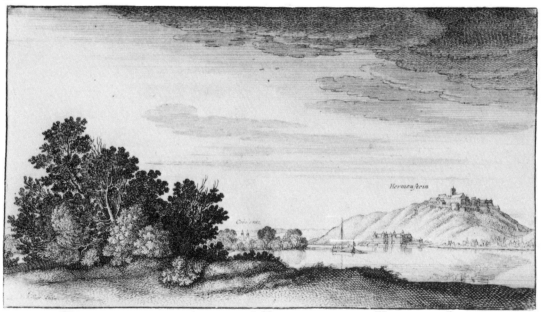

60

both dated 1635, are on 16 *recto* and 13 *verso* in the sketchbook in the John Rylands Library, Manchester (see R. Pennington, *op. cit.*, p. lxiii). Two other drawings with a view of *Ehrenbreitstein, vulgo Hermenstein* looking directly across the river from the opposite bank, one at Chatsworth and the other formerly belonging to Sir Bruce Ingram, are related to the etching *Zu Cobolentz* (R. Pennington, *op. cit.*, p. 122, no. 709).

Wenceslaus Hollar

60 *View of Hermenstein*

Etching. 9.5 × 17 cm
Literature: R. Pennington, *op. cit.*, p.124, no.724; the
 owner's private catalogue, p.247, Album no.73b.
Inscribed above the hill on the right, *Hermenstein*, and in
 the centre, *Cobolentz* (above the twin towers of St
 Castor).

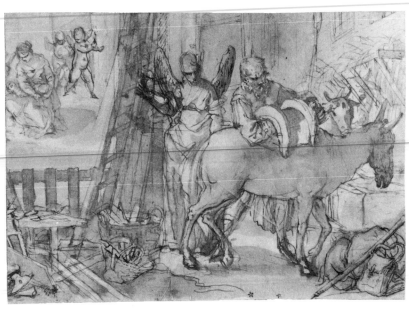

61

Johann Rottenhammer

(Munich 1564–Augsburg 1623)

61 RECTO: *The Preparations for the Flight into Egypt*

VERSO: *An Angel holding a Lantern*

Pen and brown ink with brown wash, over an underdrawing in black chalk. 15 × 21.2 cm
Provenance: Nicholas Lanière (Lugt, 2886).
Literature: *Ten German Drawings*, in Museum pamphlet, Boston, Museum of Fine Arts, 1958; the owner's private catalogue, p.87, no.36.

This drawing is reproduced with minor alterations in an engraving by Justus Sadeler, who from 1596 was working in Venice. In discussing Sadeler's print Peltzer (*Jahrbuch des Allerhöchsten Kaiserhauses*, xxxiii, 1916, pp. 333–4) drew attention to the intimate character of the work and subtle use of light effects illuminating the interior which are also found at that period in the small paintings on copper by Adam Elsheimer, like his *Jupiter and Mercury in the House of Philemon and Baucis*, done about 1608–9 when he was

likewise in Italy. No known painting by Rottenhammer based on this drawing appears to have survived.

Johann Rottenhammer

62 *Venus and Cupid*

Pen and brown ink with grey wash on red tinted paper. 10.6 × 15.1 cm
Literature: the owner's private catalogue, p.195, Album no.42.

This is very probably a sketch for a wall-painting recorded as executed in 1611 for the house of Matthäus Hopfer, the 'Haus in der Grottenau' in Augsburg, in which was painted 'Veneres virtutis et vanitatis' (R. A. Peltzer, *Jahrbuch des Allerhöchsten Kaiserhauses*, xxxiii, 1916, no. B. 18). A similar composition was used earlier in a pen drawing of 1601, *A Sleeping Woman with a Boy in a Landscape* in Darmstadt (R. A. Peltzer, *op. cit.*, p. 324).

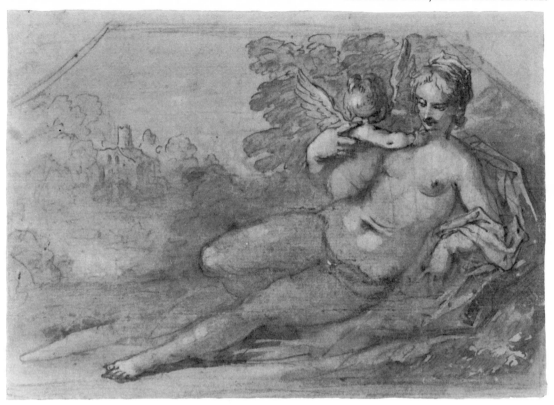

62

Matthias Kager (Munich 1575–Augsburg 1634)

63 *The Beheading of St Catherine*

Pen and black ink with red, purple, blue, brown and grey
 washes, squared in black and red chalk. 24.7 × 18.8 cm
Provenance: Winckler, sale, Frankfurt am Main, F.A.C.
 Prestel, 1920, 10 November, lot 82; Robert von Hirsch,
 sale, Sotheby's, 1952, 18 June, lot 29 as by 'Christoph
 Schwarz'.
Literature: Georg Swarzenski–Edmund Schilling,
 Handzeichnungen aus deutschem Privatberitz, Frankfurt
 am Main, 1924, no.25 as 'attributed to Rottenhammer';
 the owner's private catalogue, p.91, no.38.

Kager began his career working for court and
church in Munich, but moved to Augsburg in 1603.
In his works for the City of Augsburg he assumed an
official style in which he simulated the grand man-
ner sufficiently to satisfy the city fathers. In his
religious works he managed to retain a picturesque
charm which is effected here by the rather capricious
use of washes, lightly applied.

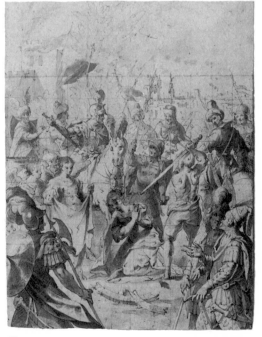

63

Johann Wolfgang Dieterich
(Weikersheim 1616–?85)

64 *Fortuna: 'Cura Atque otio'*

Pen and brown ink with grey wash. 9.6 × 15.7 cm
Literature: E. Grünenwald, 'Ein Beitrag zum Werk des
Malers Johann Wolfgang Dieterich . . . ', Festschrift für
Gerd Wunder, *Württembergisch Franken Jahrbuch*, lviii,
1974, pp.238, 241; the owner's private catalogue, p.251,
Album no.75.

Following his verses on the rarity of true friendship, the
artist has inscribed to the owner of the *album amicorum*,
now unknown, the dedication, *zu gutem Angedenken
mache dieses Hannss Wolf Dieterich Mohler Ötting[en]den
19 July 1671*.

This sheet, which comes from an *album amicorum*, is
decorated typically with the figure of *Fortuna*,
almost certainly the commonest allegory on such
pages recording regard for the intended recipient.
Sandrart executed an engraving after a portrait by
Dieterich of Graf Joachim Ernst von Öttingen
(1612–59) for whom he may possibly have worked
on a regular basis.

Norbert Grund (Prague 1717–67)

65 *Dancing in the Open Air*

Brush drawing with grey wash. 6.6 × 19.1 cm
Provenance: Freiherr A. von Lanna.
Literature: the owner's private catalogue, p.105, no.45.

As pointed out by Bruno Bushart, the figures in this
sketch agree closely with groups in a print of the
*'Lusthaus alla Mira, Casa Goimanni genandt, zwischen
Padoa und Venedig'* in the appendix of the *Iconog-
raphia* of Johann Wilhelm Baur (*c.* 1600–40) pub-
lished by Melchior Küsell at Augsburg in 1682.
Even so, the Collector maintained his attribution of
the drawing to Grund on the reasonable stylistic
ground that its execution is quite unlike Baur's.
Perhaps the answer is that Grund copied these
figures out of interest and for possible adaptation for
use in one of his own paintings.

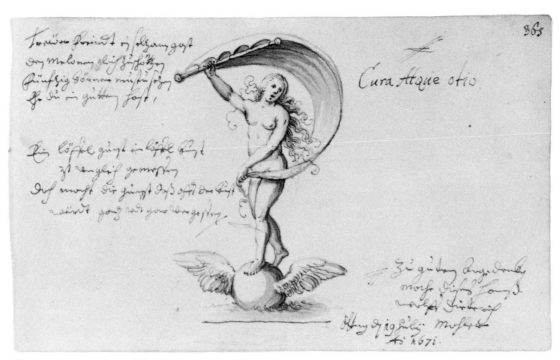

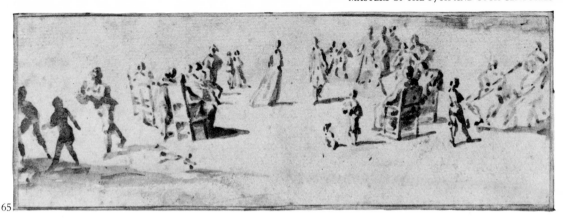

65

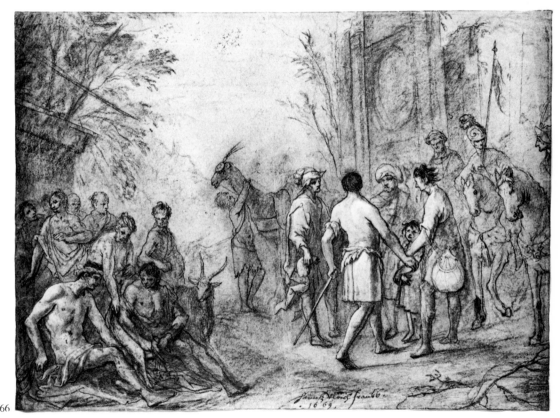

66

Hans Ulrich Franck
(Kaufbeuren 1603–Augsburg 1675)

66 *Joseph being sold by his Brothers*

Black chalk (or charcoal), pen and black ink and wash,
heightened with white chalk on yellow paper.
37.5 × 52.6 cm
Literature: *Augsburg Barock*, exh. cat., Augsburg, 1968,
pp. 182–3, no. 215; the owner's private catalogue, p. 107,
no. 46.

Inscribed by the artist in black ink on the lower edge,
Hans Ulrich Frankh 1669.

Although Franck worked also as a painter, he is
remembered chiefly for his series of etchings,
executed between 1643 and 1656, recording the
horrors of the Thirty Years' War. The present draw-
ing strongly reflects the influence of the leading
Augsburg painter, Johann Heinrich Schönfeld
(1609–82/3) on Franck after Schönfeld's return from
Italy in 1651 or 1652, where he had absorbed much
of the elegance of his Neopolitan contemporaries.

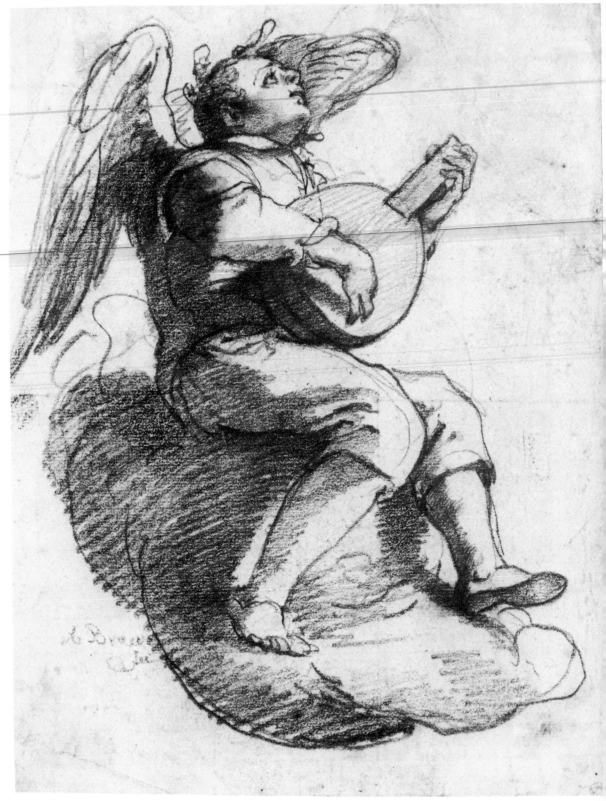

67

Augustin Braun (Cologne
c. 1570–Cologne after 1627)

67 An Angel playing a Lute seated on a Cloud

Black and red chalks. 25.5 × 19.7 cm
Provenance: sale, Sotheby's, 1966, 7 July, lot 92.
Literature: H. Vey, *Wallraf-Richartz Jahrbuch*, xxxii, 1970,
 p.276; the owner's private catalogue, p. 89, no.37.
Inscribed by the artist in black chalk on the left below the
 cloud, *A. Braun fec.*

Braun executed a wide variety of work strongly
influenced by the contemporary Flemish school
from religious paintings for the churches in Cologne
to designs for engraved views of the city, and religi-
ous engravings. But nowhere does he manage to rise
above a good level of competence. The present
drawing in chalk is, however, a notable exception,
and is the first of its type to be known. For as Vey has
pointed out, the figure of the angel has evidently
been drawn from a model in the studio with the
imaginative addition of the clouds and wings. The
vigorous execution here is not matched elsewhere
among his drawings, the majority of which are
designs in pen rather too much in the routine man-
ner of the designers of devotional prints at Antwerp.

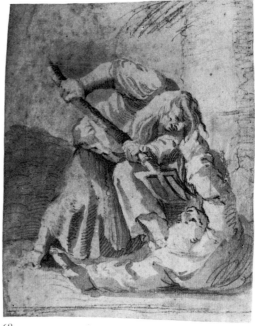

68

Johan Liss (Holstein
c. 1595/6–Venice c. 1629/30)

68 A Peasant Couple fighting

Pencil, oily charcoal, with grey wash on off-white paper.
 25.3 × 20.6 cm
Provenance: Sir Thomas Lawrence (Lugt, 2445).
Literature: E. Schilling, in *Festschrift Karl Lohmeyer*, 1954,
 pp.30–38; K. Steinbart, *Saggi e Memorie di Storia
 dell'Arte*, ii, 1959, pp.164–5; the owner's private
 catalogue, p.101, no.43.
Inscribed by an early hand on the *verso*, *Gian Liss*.

From the time of the Peasants' Wars at the beginning
of the sixteenth century these country folk had been
the subject of much satirical comment. The violent
brawl depicted here also occurs in a larger composi-
tion of peasants fighting by Liss, the design of which
is in Hamburg (*Johann Liss*, exh. cat., Augsburg,
1975, p. 137, no. B.43).

Joachim von Sandrart
(Frankfurt am Main
1608–Nuremberg 1688)

69 *Portrait of Hans von Aachen*
 (Cologne 1552–Prague 1615)

Brown chalk. 9.3 × 8 cm
Provenance: John Brophy, sale, Sotheby's, 1964, 8 July,
 lot 144.
Literature: *German Art 1400–1800*, exh. cat., Manchester,
 City Art Gallery, 1961, no.203; the owner's private
 catalogue, p.213, Album no.53.

Sandrart executed this design for the portrait
engraving that he included, together with the
engravings of all the artists whose lives and works he
discussed, in his famous treatise, *Teutsche Academie
der Bau-, Bild- und Mahlerey-Künste,* 1675.

69

Adam Elsheimer (Frankfurt am
Main 1578–Rome 1610)

70 *Landscape with a Castle on the crest of
 a Hill*

Brush drawing in black and white bodycolour on brown
 prepared paper. Unequally cut on the left.
 13.4 × 19.3 cm
Provenance: 1st Earl of Burlington (?his inv. no.352 in red
 ink); by descent to Richard Cavendish, Holker Hall,
 Cark in Cartmel, sale, Christie's, 1957, 15 July, lot 44.
Literature: *Ten German Drawings* in Museum pamphlet,
 Boston, Museum of Fine Arts, 1958; H. Möhle, *Die
 Zeichnungen Adam Elsheimers,* Berlin, 1966, no.56; *Adam
 Elsheimer,* exh. cat., Städelsches Kunstinstitut,
 Frankfurt am Main, 1966–7, no.157; the owner's
 private catalogue, p.93, no.39.

The same castle, according to Möhle, occurs again in
similar compositions of two pen drawings, *The
Hilly Landscape with a Castle* in Copenhagen (Möhle,
op. cit., no. 30) and *The Hilly Landscape with a Castle
and Town* in the Courtauld Institute of Art, London
(Möhle, *op. cit.,* no. 31). Möhle considered that this
drawing is very close in style to the *Moonlit Land-*

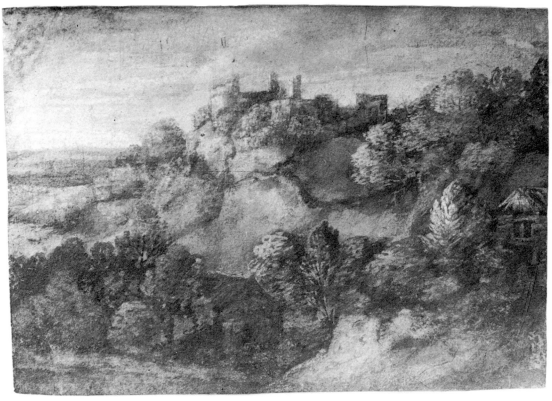

70

scape with a Wooded Lakeside in the Victoria and Albert Museum (Möhle, *op. cit.,* no. 59). While it is true that the foliage of some of the trees in the latter is freely executed, the present drawing as a whole is far more freely drawn. The contours of the hillside are moulded by the areas of deep shadows and sunlit fields and tops of trees. This use of light and shade, achieved through such deft brushwork, is to be found in another gouache landscape, formerly in the collection of Robert von Hirsch, whose composition is related to the background of the *Large Tobias,* a painting by Elsheimer, known according to Keith Andrews from a good painted copy in Copenhagen and the well-known engraving by Hendrick Goudt. Andrews takes the view that this gouache is likewise a copy based with some slight changes on Goudt's engraving (see K. Andrews, *Adam Elsheimer: Paintings–Drawings–Prints,* 1977, p. 154, no. 25). Since Möhle's publication, which was a major step for-

ward in our knowledge of Elsheimer as a draughts-man, a much more questioning view of the status of the gouache landscapes of Elsheimer has been advocated. No longer are they considered by some authorities, as Möhle did, the most securely attributed drawings by Elsheimer. First, it has been pointed.out that not all these landscapes have been executed by the same hand. A number, like that at Rennes, are clearly Dutch in style and subject-matter and some are certainly by a follower of Rembrandt, Pieter de With (active *c.* 1650–60). As Andrews has pointed out, one of the finest of these 'Elsheimer' landscapes bears the authentic signature of Gerrit van Battem (*c.* 1636–84), but it is not as yet clear to what extent this should influence scholarly opinion to make a wholesale attribution of the 'Elsheimer' gouaches to van Battem. In my view, one must at least seriously consider redating some to the 1650s or slightly later.

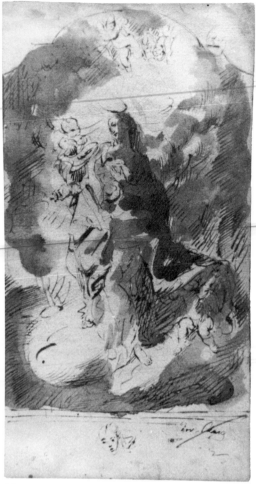

71 *recto*

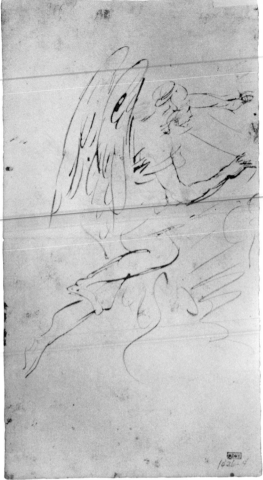

71 *verso*

Cosmas Damian Asam
(Benediktbeuren 1686–Weltenburg 1729)

71 RECTO: *The Virgin in Glory*
VERSO: *Study of an Angel*

RECTO: Pen and brown ink with grey wash.
VERSO: Pen and brown ink. 25.4 × 14 cm
Literature: *German Drawings . . .*, the Courtauld Institute
 Galleries, 1969/70, no. 59; the owner's private catalogue,
 p.113, no.49.
Inscribed by the artist in brown ink in lower right-hand
 corner, *Dom A . . .*, with a doodle of a man's head.

This is evidently a freely executed first idea for an
altarpiece, which at the next stage would be redrawn
more carefully on a larger scale, if approved by the
client, and would be squared off in chalk for transfer
to the canvas. An outstanding example of this more
elaborate type of drawing with a fairly similar com-
position is the drawing *The Coronation of the Virgin*
in the Albertina, Vienna, inv. no. 3825 (Otto
Benesch, *Meisterzeichnungen der Albertina . . .*, 1964,
pp.347–8, no.111).

Melchior Steidl (Innsbruck
c. 1657–Munich 1727)

72 *The Assumption of the Virgin*

Pen and brown ink and grey wash. 29.4 × 17.9 cm
Inscribed by the artist in brown ink at the foot of the
 drawing, *Melchior Steidl mahler F: I: gezeichnet in
 Ellwange[n] Ao : 1711.*
Literature: the owner's private catalogue, p.111, no.48.

This is a sketch for the principal ceiling fresco in the
Schönenbergkirche near Ellwangen (see B. Bushart,
Festschrift Eberhard Hanfstaengel, Munich, 1961, pp.
96 ff).

72

73

Martin Johann Schmidt, called 'Kremserchmidt'
(Grafenwörth 1718–Stein an der Donau 1801)

73 *Allegory of Painting, Sculpture, and Design*

Pen and brown ink with grey wash. 29.7 × 18.7 cm

Literature: *Ten German Drawings* in Museum pamphlet, Boston, Museum of Fine Arts 1958; the owner's private catalogue, p. 115, no. 50.

Schmidt has had the reputation for being the best eighteenth-century painter and draughtsman in Austria after Franz Anton Maulbertsch (1724–96). Like the Tiepolos he was a prolific draughtsman, and would sell his drawings by the album to interested amateurs and connoisseurs throughout Europe.